W9-CUZ-261

Hunters, Carvers & Collectors

PEABODY
MUSEUM
COLLECTIONS
SERIES

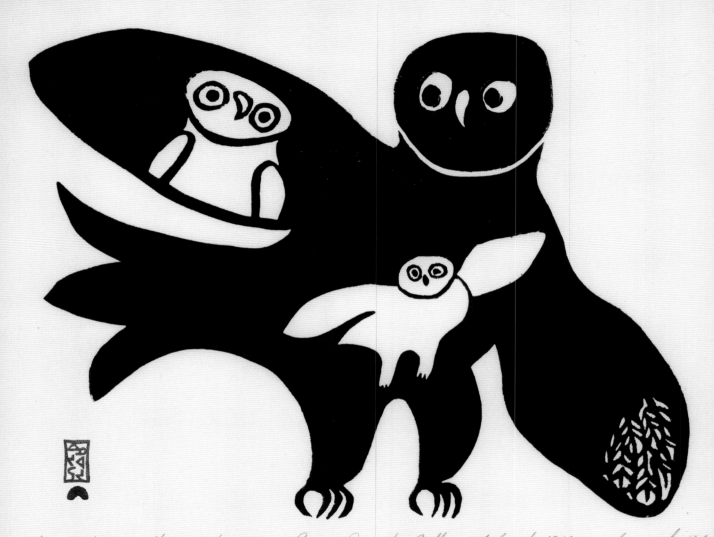

Female Owl Stone cut 18/50 Cape Dorset Baffin Island 1960. Innukjuak

HUNTERS, CARVERS & COLLECTORS

The Chauncey C. Nash Collection of Inuit Art

Maija M. Lutz

Foreword by Leslie Boyd Ryan

Photographs by Mark Craig

Rubie Watson, Series Editor

Peabody Museum Press, Harvard University
CAMBRIDGE, MASSACHUSETTS

Editorial direction by Joan K. O'Donnell
Copy editing by Jane Kepp
Cover design by Kristina Kachele and Joan K. O'Donnell
Text design and composition by Kristina Kachele Design, llc
Production management by Donna Dickerson
Proofreading by Janice Herndon and Donna Dickerson
Prepress by FCI Digital, West Carrollton, Ohio
Printed and bound in China at Everbest Printing Co., Ltd., through Four Colour Print Group

ISBN 978-0-87365-407-4

Library of Congress Cataloging-in-Publication Data:
Lutz, Maija M.
Hunters, carvers, and collectors : the Chauncey C. Nash collection of Inuit Art /
Maija M. Lutz; foreword by Leslie Boyd Ryan ; photographs by Mark Craig.
p. cm.
Includes bibliographical references.
ISBN 978-0-87365-407-4 (pbk. : alk. paper)
1. Inuit art. 2. Nash, Chauncey Cushing, 1884–1968—Art collections 3. Peabody Museum of Archaeology and Ethnology. I. Peabody Museum of Archaeology and Ethnology. II. Title.
E99.E7L87 2012
704.03'9712—dc23
 2012003299

This book is printed on acid-free paper.

PEABODY MUSEUM PRESS
11 Divinity Avenue
Cambridge, MA 02138, U.S.A.
www.peabody.harvard.edu/publications/

FRONTISPIECE: Inukjuakjuk Pudlat (1913–1972), *Female Owl*. Stonecut printed by Lukta Qiatsuq, Kinngait (Cape Dorset), 1960. 18/50 (Number 18 of an edition of 50). Print size 32 × 39.3 cm. PM 61-22-10/39042. 9881016.

FRONT COVER: Kenojuak Ashevak (b. 1927), *Bird Humans*. Linocut printed by Eegyvudluk Pootoogook, Kinngait (Cape Dorset), 1960. 17/50. 60.5 × 72.2 cm. PM 61-22-10/39043. 98810008.

BACK COVER: Jacques Kabluitok (1909–1970), *Owl*. Kangiqliniq (Rankin Inlet), c. 1965. Stone sculpture signed with syllabics and disc number (E3–85). 16 × 7.5 × 11 cm. PM 65-7-10/44107. 98830017. Mark Craig, photographer.

Contents

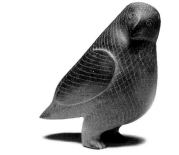

Illustrations

PLATES

COLLECTING THE STORIES
OF CONTEMPORARY INUIT ART

Leslie Boyd Ryan

THE PEABODY MUSEUM'S CHAUNCEY C. NASH collection of Inuit art first
came to my attention in 2008, when Maija Lutz wrote to me at Dorset Fine Arts,
where I am director. Her initial inquiries revolved around image reproduction and
copyright, because Dorset Fine Arts is the marketing agent for the artist members
of the West Baffin Eskimo Co-operative in Cape Dorset (Kinngait), Canada, and
acts as agent in matters of copyright. From there our discussion began to branch out
as Lutz's meticulous research led her to the many books and articles that have been
published over the years on the ever-changing world of contemporary Inuit art.

My first comment upon reading Lutz's comprehensive manuscript was that I
believe I would have liked Mr. Chauncey Nash. Many of the details of her portrait of
this generous and discerning collector reminded me of my American family roots in
New England. Mine is also a family of collectors with a keen interest in indigenous
art, especially that of the Native peoples of the American Southwest. So I felt a par-
ticular affinity with both the man and his pursuit.

My own involvement in contemporary Inuit art dates to the summer of 1980 in Cape Dorset, when I discovered the archive of proof prints that have been kept as a record of print editions released as annual collections since 1959. Cloistered in a room adjacent to the cooperative's bustling lithography and etching workshops, which are known as Kinngait Studios, I began organizing and cataloguing these prints; they served as my introduction to Inuit graphic art. Many of the artists were still alive at the time and bringing drawings to the studios, so I gradually put faces to names and linked those names to the styles and subjects that characterized their work. I also got to know many of the artists and printmakers personally, language barrier notwithstanding.

It has always been a particular concern of mine to relate the discussion of contemporary Inuit art to the individual artists who created it, and in *Hunters, Carvers, and Collectors* Lutz does this with sensitivity and insight. She devotes a great deal of attention to the biographies of the artists represented in the Nash collection and to the stylistic and aesthetic concerns that distinguish one from another. Here we have Kenojuak Ashevak, the aesthete, whose motivation has always been "to make something beautiful." In contrast we have Kiakshuk, the hunter, shaman, and storyteller, whose narrative approach inspired others of the "first" generation of Inuit graphic artists to commit their life experiences to paper. Pitseolak Ashoona was inspired by Kiakshuk, and she in turn is credited by many of the second, third, and now fourth generations of artists as their source of inspiration.

The Nash print collection includes images made from 1959 through 1967, the formative years of the printmaking program at Kinngait Studios. Many of these images are now considered classic and are highly valued by collectors. It is no mystery why these prints are so celebrated: they stand the test of time for their originality, aesthetic merit, and technical expertise, especially in light of the circumstances of their creation. Those circumstances, not surprisingly, are surrounded by romance and mystique, given their particular convergence of place— the Canadian Arctic, long defined by adventure and mystery—and personality— specifically the larger-than-life presence of James Houston. Lutz well and justly recognizes Houston's role in the development and promotion of Inuit art, and she

touches on the supporting role played by the Canadian Handicrafts Guild (now the Canadian Guild of Crafts). Its efforts to support Inuit arts and crafts date back to 1930, and it sponsored Houston's travel and purchases of Inuit carvings for resale by the guild in 1949 and for several years thereafter.

When Houston and his family took up residence in Cape Dorset in 1956, they did so under the auspices of the Canadian government. The "craft shop" there was the government's first attempt to organize the production of Inuit arts and crafts toward a sustainable community economy, and it led to a pan-Arctic cooperative development program that fostered the creation of twenty cooperative organizations across the north in its first five years. (There are now thirty-one community cooperatives across Nunavut and the Northwest Territories.) Of those twenty, fourteen were involved in some way with arts and crafts—not surprisingly, for as Donald Snowden, then head of the Industrial Division of the Department of Northern Affairs, famously observed, economic resources at the time "in most areas [were] limited to stone, bone, animal skins and the human skills to make something from them."

The West Baffin Eskimo Co-operative in Cape Dorset was the first to be incorporated under the federal program in 1959. It emerged as one of the strongest and most successful of the Arctic associations, and the extent to which it has remained focused on the arts is unprecedented. But the salient point about all these organizations is that they are wholly owned by the Inuit residents of the communities and are governed by elected representatives to the boards of directors. This is of enormous significance in a region traditionally dominated by "outside" interests and in remote communities where the cost of living is now nearly four times higher than the national average.

Economic necessity underlay the development of contemporary Inuit art, and Inuit artists have been unabashed in acknowledging the monetary motivation behind what they do. They have been less direct about the social and political benefits that art provides to the community as a whole, although some Inuit artists, such as Kananginak Pootoogook, have identified the relationship between art making and their own cultural development. Lutz writes of a "dual audience" for contemporary

Inuit art, recognizing that even though the art has been created for an outside audience, it also helps to define Inuit reality and identity in rapidly changing times.

The relationship between contemporary Inuit art and cultural development is ongoing. One significant project in this regard is an effort to digitize and create an interactive database of the vast archive of original drawings that have been collected since the beginning of the Cape Dorset print program and that now represent four generations of Inuit artists. They are a legacy of enormous artistic and cultural significance. The database will make these images accessible worldwide, and more important, it will bring the legacy back to the Inuit people—the grandchildren and great-grandchildren of the artists who created the works.

The generosity and forward thinking of collectors such as Chauncey Nash are invaluable to this ongoing legacy. In donating these seminal works to his alma mater, he ensured that future generations would be able to enjoy some of the best examples of contemporary Inuit art. This would please the artists represented here, for it was always their intention to share their culture and way of life with the outside world. It is true, as Lutz writes, that each of these works has a story to tell, and they reward close attention.

Acknowledgments

THIS PROJECT WOULD NOT HAVE BEEN undertaken or completed without the encouragement, enthusiasm, and assistance of many people. First and foremost, I am grateful to Rubie Watson, former director of the Peabody Museum, and Susan Haskell, curatorial associate, for calling my attention to this superb collection and suggesting that I curate a small exhibition of the works. This book is an outgrowth of that exhibit, titled *The Raven and the Loon,* which was mounted in 1999 under the skillful direction of Sam Tager.

My thanks go to both Susan Haskell and Pat Kervick, associate archivist at the Peabody Museum, for being always accommodating in giving me access to both the collection and its documentation, sometimes on very short notice. My former colleagues at the Tozzer Library kept a vigilant eye out for any and all new publications on Inuit art, and I am greatly indebted to them for their thoughtfulness and interest in my project.

I owe special thanks to Chandler Gifford Jr., Chauncey C. Nash's nephew, who shared with me valuable insights about his uncle's personality and interests. He also read the sections of the manuscript pertaining to his uncle and offered helpful comments. I was fortunate to have access to the resources of the Harvard University Archives and Houghton Library for materials on Nash's college years at Harvard, his society memberships, and his later association with the university. I want especially to thank Robin McElheny, of the University Archives, for her assistance.

The book benefited greatly from the input of several experts in the field of Inuit art. Leslie Boyd Ryan reviewed an earlier version of the manuscript and offered many insightful comments and suggestions. Janet Catherine Berlo and an anonymous reader made valuable suggestions for improving the manuscript and bringing this remarkable art to life. I thank all three for sharing their knowledge and expertise with me. Several people helped me with my search for biographical information about artists. I especially thank Patrick Kabluitok for providing me with birth and death dates for his father, Jacques.

I am grateful to Mark Craig for his beautiful photographs of the sculptures, and to Widener Library Imaging Services for its fine reproductions of the prints. Peabody Museum conservators T. Rose Holdcraft and Scott Fulton assessed and treated every object as necessary to assure that each was in optimum condition before being photographed. Publication of these works from the Peabody Museum collection would not have been possible without the much-appreciated assistance of Leslie Boyd Ryan at Dorset Fine Arts and the Inuit Art Foundation in securing copyright permissions from the artists or their representatives. I also thank William Ritchie, Tessa Macintosh, and David Zimmerly for providing me with their outstanding photographs of artists at work, and Lorraine Brandson for granting me permission to use photographs owned by the Eskimo Museum in Churchill, Manitoba. Several other institutions gave me permission to reproduce images from their collections, and I thank them as well. I also thank my former colleague Charles Fineman for translating a necessary text from Danish into English.

Special thanks go to Joan O'Donnell, director of publications at the Peabody Museum, and Donna Dickerson, project manager, together with Jane Kepp (copy

editor), Kristina Kachele (designer), and Deborah Reade (cartographer), for their talents and efforts in bringing this book to fruition. I am especially grateful to Joan for her patience, support, encouragement, and editorial guidance during every stage of this lengthy process, to Jane for her meticulous and insightful copyediting, and to Donna for ensuring that no detail of the publication process is overlooked.

Many friends and colleagues gave me continuous support and encouragement during the writing of this book, and I thank them for their enthusiasm, interest, and forbearance.

Finally, I want to acknowledge the incredible support of my husband, Peter Tassia, who helped me in ways too numerous to count. This book is his as much as it is mine.

AUTHOR'S NOTE

THROUGHOUT THIS BOOK the name *Inuit* is used to refer to the Native peoples of the Canadian Arctic, who were formerly known to outsiders as Eskimos. Inuit, meaning "the people," is the traditional term used and preferred by the people themselves and is quickly gaining universal usage among others. Exceptions in which I retain the word *Eskimo* include titles of certain books, articles, and works of art, historical contexts in which *Eskimo* might be more appropriate, and references to the entire Arctic region, because using *Inuit* to denote all Arctic peoples would be linguistically incorrect.

Artists' names appear as they are found in current common usage. Traditionally, Canadian Inuit had only one name, but as the federal government became increasingly involved in their lives, new identification systems were devised. The first system, in which the government assigned each person a unique identifier number, was introduced in 1941. These numbers, printed on circular discs and worn around the neck, were used until 1970, when they were replaced by Operation Surname. Under

this system, the traditional name of the head of the family usually became the surname for the other family members. Over the years, many variant spellings of names have existed, some of which continued to be used even after a standard Roman orthography for the Inuktitut language became established. Many artists are still known and referred to today primarily by their traditional given name.

Place names have likewise undergone many changes over the years. Nowadays preference is given to the Inuktitut forms of names, even though not all communities have adopted such names officially. In this book I use the Inuktitut forms for communities, with the alternate (and sometimes still officially recognized) name given in parentheses in the interest of clarity. All communities referred to in the text appear on the map on page 4 with both Inuktitut and alternative names.

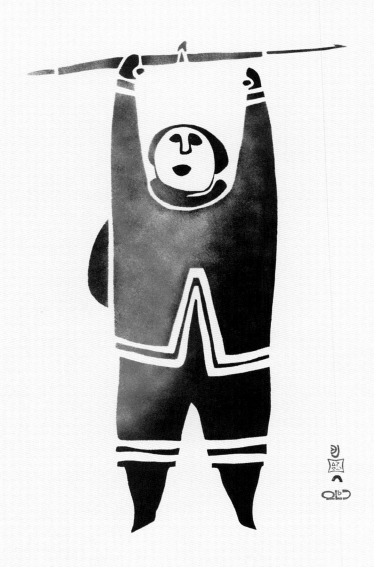

Joseph Pootoogook (1887–1958), *Hunter's Signal.* Stencil printed by Eegyvudluk Pootoogook, Kinngait (Cape Dorset), 1961. 34/50 (Number 34 of an edition of 50). Print size 64 × 48.2 cm. PM 62-3-10/40700. 98810031.

*Long ago the weapons used by the Inuit were harpoons, spears,
and bows and arrows. Harpoons were used for hunting seal,
walrus and whale, whereas spears were used for game such
as the polar bear, caribou and rabbit. The hunter required
skill and speed in order to achieve success at hunting.*
—Kananginak Pootoogook (1935–2010),
in *Dorset 81* (Cape Dorset print catalogue, 1981)

PREFACE

A PICTURE CAN CREATE A WORLD, igniting viewers' imaginations and taking
them far away from their everyday surroundings. A single glance at the image on the
facing page—the bold figure of an Inuit hunter holding his spear aloft, signaling to
someone with apparent urgency—immediately elicits our curiosity. Who is this man,
and what is he hunting? What does his signal mean? Is he urging others to follow him
in pursuit of game? Alerting them that he has killed an animal? Summoning help?
Or did the artist intend simply to depict a hunter and one of the weapons used in the
hunt, without implying a story at all?

The formal features of the figure, such as details of the clothing and the man's
disproportionately small hands and feet, prompt other questions. Why did the artist
portray him this way? Who, indeed, was the artist? What techniques did he or she
use to produce this striking work, and what cultural and personal circumstances
surrounded its creation? How did it come to reside in a museum of archaeology and
ethnology in Cambridge, Massachusetts?

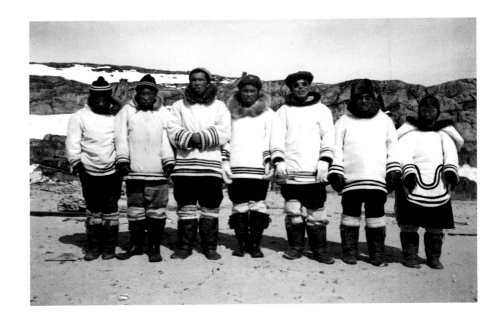

Joseph Pootoogook and his family, probably in the 1950s. From left: sons Kananginak, Eegyvudluk, Paulassie, Pudlat, and Solomonie; Pootoogook; and his wife, Ningeookaluk. This photograph was one of some two thousand taken by Pootoogook's brother, Peter Pitseolak (1902–1973), documenting the waning days of Inuit camp life. Photo © Canadian Museum of Civilization, Peter Pitseolak, 2000-1159.

This single print introduces us to its creator, the Inuit artist Joseph Pootoogook (1887–1958), a highly respected hunter and camp leader who, together with his remarkably talented family, played a founding role in the development of contemporary Inuit art. It also introduces Chauncey C. Nash, the man who collected this and several hundred other Inuit prints and sculptures—dating mostly to the 1960s, the early years of contemporary Inuit art making—and donated them to Harvard University's Peabody Museum of Archaeology and Ethnology.

Every object in the Chauncey C. Nash collection has a story to tell. Taken together, these stories, or "cultural biographies," paint a fascinating picture of artistic vision and creativity, economic necessity, and cultural definition and redefinition. In the pages of this book I explore the collection and describe how these wonderful works, which were created for outsiders yet also played important roles in the artists' own communities, came to reside at Harvard and how they continue to elucidate nineteenth- and twentieth-century Inuit life for twenty-first-century viewers.

Hunters, Carvers & Collectors

Pauta Saila (left) and James Houston in the print studio, Kinngait, 1961. © Government of Canada. Reproduced with the permission of the Minister of Public Works and Government Services Canada (2010). Source: Library and Archives Canada/Credit: B. Korda/National Film Board of Canada. Photothèque collection/PA-146514.

CONTEMPORARY INUIT ART

WHILE ON A PAINTING TRIP to northern Ontario in 1948, a young Canadian artist named James A. Houston (1921–2005) accepted a sudden offer of a free plane ride to the Inuit settlement of Inukjuak in Nunavik (Arctic Quebec). Little did he know that this unexpected visit would turn into a fourteen-year stay in the Arctic and pave the way for what the world now knows as contemporary Inuit art. Throughout Houston's years in the Arctic, first as a crafts officer for the Canadian Handicrafts Guild and later in a similar role for the Canadian federal government, he worked closely with local Inuit to develop and promote artwork that could be sold to outsiders, along with markets for that work.

When Houston first saw Inuit sculpture in 1948, visitors to the Arctic were already well acquainted with Inuit carvings in ivory and stone and collected them eagerly. Yet the art remained little known outside the region. The Hudson's Bay Company and other groups had previously attempted to stimulate the local economy by creating a larger market for Native handicrafts, but their efforts had been unfruitful.

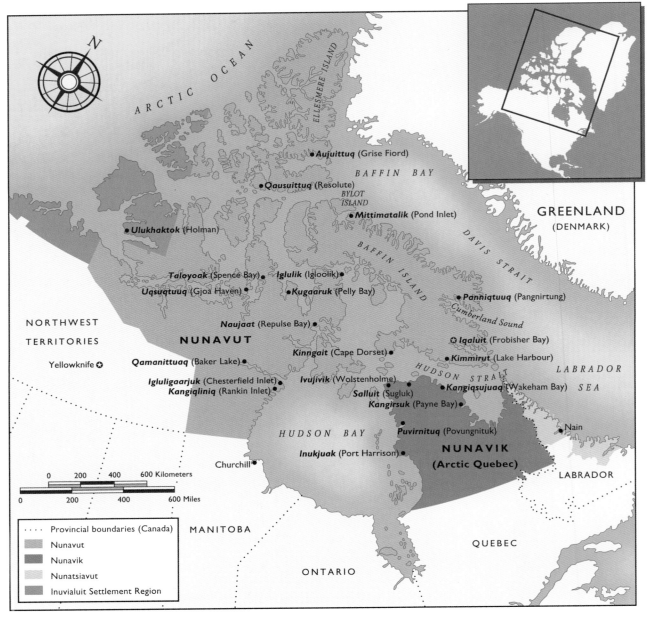

ARCTIC OCEAN

ELLESMERE ISLAND

● **Aujuittuq** (Grise Fiord)

BAFFIN BAY

● **Qausuittuq** (Resolute)

BYLOT ISLAND

● **Mittimatalik** (Pond Inlet)

GREENLAND
(DENMARK)

● **Ulukhaktok** (Holman)

BAFFIN ISLAND

DAVIS STRAIT

Taloyoak (Spence Bay) ● ● **Iglulik** (Igloolik) ●

Uqsuqtuuq (Gjoa Haven) ● ● **Kugaaruk** (Pelly Bay)

● **Panniqtuuq** (Pangnirtung)

Cumberland Sound

NORTHWEST

TERRITORIES

NUNAVUT

Naujaat (Repulse Bay) ●

⊙ **Iqaluit** (Frobisher Bay)

Yellowknife ⊙

Qamanittuaq (Baker Lake) ●

Kinngait (Cape Dorset) ●

● **Kimmirut** (Lake Harbour)

LABRADOR

HUDSON STRAIT

SEA

Igluligaarjuk (Chesterfield Inlet) ●

Ivujivik (Wolstenholme) ●

Kangiqliniq (Rankin Inlet) ●

Salluit (Sugluk) ●

● **Kangiqsujuaq** (Wakeham Bay)

Kangirsuk (Payne Bay) ●

● Nain

HUDSON BAY

Puvirnituq (Povungnituk) ●

Inukjuak (Port Harrison) ●

NUNAVIK
(Arctic Quebec)

LABRADOR

Churchill ●

0 200 400 600 Kilometers

0 200 400 600 Miles

MANITOBA

QUEBEC

······ Provincial boundaries (Canada)

Nunavut

Nunavik

Nunatsiavut

Inuvialuit Settlement Region

ONTARIO

The Canadian Arctic, showing the Inuit regions of Canada and place names mentioned in the text.
Map by Deborah Reade.

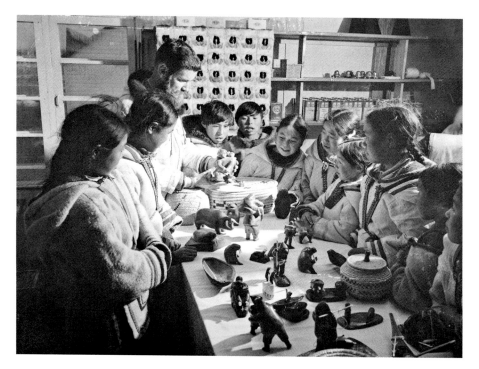

James Houston displaying a selection of carvings and crafts in Panniqtuuq, Nunavut, c. 1951. Left to right: Leah Qaqqasiq, Taina Nowdlak, James Houston, Levi Nutaralaaq, Joanasie Maniapik, Sheepa Ishulutaq, Rosie Veevee, Miluqtuarjuk Arnaqquq, Towkie Qappik. © Government of Canada. Reproduced with the permission of the Minister of Public Works and Government Services Canada (2010). Source: Library and Archives Canada/National Film Board of Canada. Still Photography Division/PA-189969.

Impressed by the artistic merit of the carvings he saw in Inukjuak, particularly those in stone, Houston brought a small sample of them back to Montreal to show to the directors of the Canadian Handicrafts Guild (now the Canadian Guild of Crafts). With funds raised by the guild, he returned to the north and purchased several hundred carvings, most of which the guild sold in just three days at a hugely successful exhibition in November 1949. Through subsequent marketing and publicity by the guild and Houston himself, other exhibitions, and a flurry of media reports about this newly discovered art form, the public's interest in Inuit art grew quickly in Canada, the United States, and other countries. Stone, which was more readily available than ivory, became the carving medium of choice in many Inuit communities, and its use set the stage for the large, meticulously crafted and polished stone sculptures seen in galleries today.

By 1957 Houston was living in Kinngait (Cape Dorset), an Inuit community on Baffin Island in the present Canadian territory of Nunavut, formerly the northeastern portion of the Northwest Territories. As part of his mandate to explore all arts-related projects—and building on an existing Inuit graphic arts tradition—Houston introduced area Inuit to printmaking. Works in this new medium found almost instant popularity in the North American art market. In 1959 Houston helped create the West Baffin Eskimo Co-operative, one of a number of Inuit-owned co-ops established with the help and encouragement of the federal government in response to increasing transition by the Inuit from camp life to settlement living in the late 1950s and early 1960s. The co-ops were meant to stimulate economic development and provide growing communities with new sources of income and essential services.[1] The West Baffin Eskimo Co-operative in Kinngait quickly established a reputation for excellence through its successful arts program, especially its printmaking.

Creating and selling works of art have now been defining features of many Inuit communities for more than fifty years. But the phenomenon has precursors, and James Houston was far from the first Westerner to be captivated by Inuit carvings and drawings. Indeed, the year 1771, which saw the official opening of the first Moravian mission station in Nain, Labrador, can be considered the beginning of the historic period in Inuit art, a period that lasted until Houston's efforts in the late 1940s began to spark changes.

During the historic period, Inuit began to employ materials from which they had previously fashioned utilitarian objects—walrus ivory, bone, antler, wood, bark, and stone—for a new use as objects marketable to outsiders. For example, women turned their time-honored skills in decorating fur clothing with appliqués or inlays of fur pieces in different colors to other items such as sealskin handbags suitable for trade or sale. As the demand for trade and sale goods grew with each new arrival of whalers, traders, explorers, and missionaries, so did Inuit artisans' desire to produce objects to meet the demand.

Small carvings in walrus ivory predominated at this time, and traders also encouraged the Inuit to carve stylized motifs and descriptive scenes on walrus tusks. Ample references to stone carvings, too, appear in reports of explorers and other visitors in

the nineteenth and early twentieth centuries. Of special note is a stone carving of a bowhead whale, nearly seventeen inches long, collected around 1899 in the Iglulik (Igloolik) area by Captain George Comer (1858–1937), a whaling and sealing shipmaster with an insatiable thirst for knowledge.[2] The piece is not unlike some sculptures made half a century later (pl. 18).

The carved images that Inuit offered to early Euroamerican visitors were only the latest manifestations of a long artistic heritage. Carving and image making in the Canadian Arctic can be traced as far back as approximately 2500 BC, to predecessors of the Inuit whom archaeologists call Paleo-Eskimos.[3] The later Paleo-Eskimos of Canada, known archaeologically as the Dorset people (circa 800 BC to AD 1300), are particularly well known for their art, which was closely related to ritual and shamanism. Archaeological excavations have revealed a wealth of Dorset-culture human and animal figures made of ivory, bone, and antler, as well as utilitarian objects with elaborate decoration.

Beginning around AD 1000, people belonging to what archaeologists call the Thule culture, which had developed in northwestern Alaska, began spreading eastward into Canada and ultimately Greenland. Bringing with them a rich maritime hunting tradition, they gradually replaced the Dorset people and are considered to be the direct forebears of the historical Inuit.[4] The art of the Thule people was less elaborate and more utilitarian than that of the Dorset people, consisting of decorated objects such as combs, toggles, and needle cases.[5]

Just as certain forms of carving have a long history in the Arctic, so does graphic, or two-dimensional, art. Although much remains unknown about prehistoric Inuit work that might have been done on skins and other perishable materials now lost to decom-

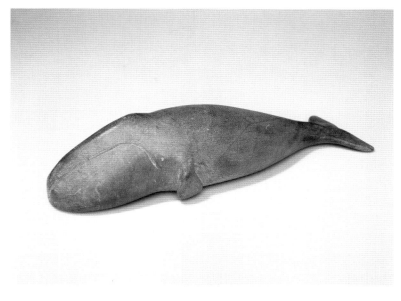

Large stone carving of a whale collected in the Iglulik area by Captain George Comer at the end of the nineteenth century. 41.5 × 12.5 × 10 cm. Courtesy of the Division of Anthropology, American Museum of Natural History, cat. no. 60/2845.

Mask, late Dorset culture, from Bylot Island, Nunavut. Masks such as this life-size wooden one, excavated by Guy Mary-Rousselière in the northern reaches of Baffin Island, were probably worn by shamans in their rituals for curing the sick and controlling weather. 18.3 × 13.4 × 4.5 cm. Photo © Canadian Museum of Civilization, PfFm-1:1728 a, b, IMG2008-0215-0015-Dm.

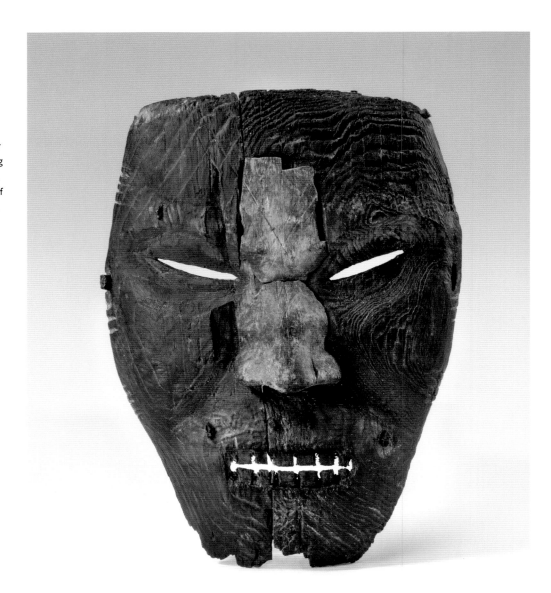

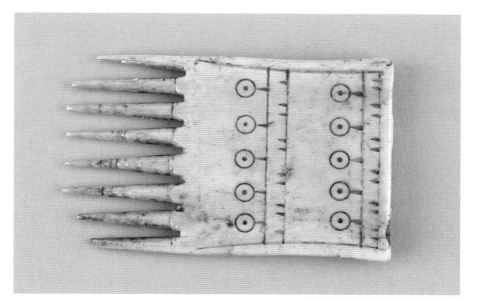

Comb, Thule culture, Nunavut. This ivory comb is a classic example of the kind of decoration with which Thule people embellished their everyday objects. 7.6 × 4.8 cm. Photo © Canadian Museum of Civilization, NaPi-2:8-23, S99-2948.

position, archaeologically excavated objects made from ivory, bone, and antler provide ample evidence of a graphic tradition. Dorset people and their predecessors sometimes used sharp stone flakes to incise magical and religious objects with symbolic skeletal lines on animals and facial markings resembling tattoos on humans. An important Dorset-era petroglyph site on an island in Hudson Strait displays faces incised with human, animal, and hybrid features. Thule people incised everyday objects with stick figures of humans and animals and, occasionally, hunting and camp scenes. Excavations in early Thule villages have uncovered engravings of hunting scenes made on bowhead whale mandibles that people used in constructing their houses.[6]

But it was with the arrival of whalers, explorers, and anthropologists, who brought with them paper and pencils, that the Inuit began to draw as we now think of drawing, often at the visitors' requests for geographical or ethnographic information. Explorers of the Canadian Arctic such as Captains John Ross and William Edward Parry obtained Inuit sketches of animals and people and hand-drawn maps of the land as early as

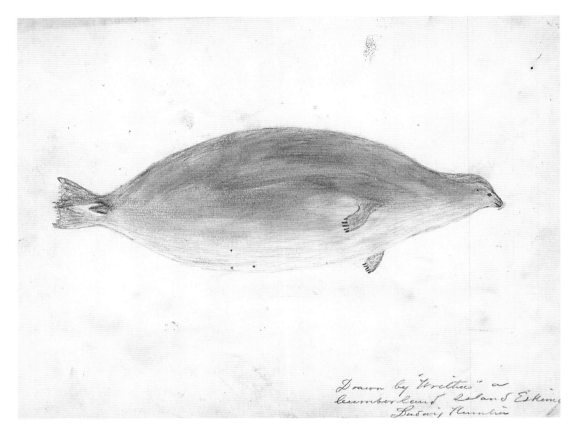

Drawn by "Wrichtau" a
Cumberland Island Eskimo
Ludwig Kumlien

Large Seal Swimming, one of four graphite drawings collected by Ludwig Kumlien that make up a folio titled "Land and Sea Animals, Inscribed 'Wrichtau, a Cumberland Island Eskimo,' November 1877." These drawings depict animals such as seals and caribou that are vital to the Inuit for year-round survival. 17.8 × 25.4 cm. National Anthropological Archives, Smithsonian Institution (NAA INV 08543100).

the beginning of the nineteenth century. Captain George Comer collected drawings depicting Inuit men's and women's clothing styles during his expeditions at the end of the nineteenth and beginning of the twentieth centuries.[7] Ludwig Kumlien, a Smithsonian naturalist wintering on Baffin Island in 1877–1878, obtained a collection of drawings, including pencil sketches of camp life and hunting activities, made by one of his Inuit companions. Other collectors of drawings depicting early twentieth-century Inuit life were Knud Rasmussen, the Danish leader of the famed 1921–1924 Fifth Thule Expedition, who traveled across the Canadian Arctic by dog

team conducting archaeological and anthropological research, and the geographer and cinematographer Robert Flaherty, who made the famous film *Nanook of the North*.[8]

As an art form with firmly established roots throughout the Canadian Arctic, drawing lent itself well to the progression toward new commercial markets that emerged in the 1960s for Inuit art in the form of prints. Modern Inuit printmaking has its own origin story, often told and sometimes embellished, which says that the impetus arose during a conversation in 1957 between Osuitok Ipellie (1922–2005), a Kinngait carver and hunter, and James Houston. In response to Osuitok's observation that it must be tiresome for someone to paint the same image over and over again on an endless number of cigarette packs, Houston demonstrated the printing process, using some engravings Osuitok had made on a walrus tusk. According to one version of the story, Houston covered the ivory with writing ink and then laid a piece of tissue paper over it. When he removed the paper, a negative image of the artist's design remained. Osuitok wanted to learn more.[9]

Soon, Houston and two or three interested young men began experimenting with printmaking, using linoleum floor tiles with a thin wood backing, pieces of local stone, and any tools available. Next they tried stenciled prints, at first cutting the stencils from sealskin. Through arrangements with the Canadian Handicrafts Guild, a number of these earliest experimental prints were exhibited in Winnipeg, and they sold immediately.

Following this success, Houston decided to spend several months in Japan studying centuries-old printing methods with a Japanese master, Un'ichi Hiratsuka (1895–1997).[10] The woodcut, the oldest form of printmaking, had been brought to Japan from China in the eighth century AD by a Buddhist missionary, and it came to play a major role in the works of European masters of both the Renaissance and the late nineteenth century. Upon Houston's return to Kinngait, he and a group of the most talented and interested Inuit printmakers began to develop techniques with which to apply his newly acquired knowledge in the Arctic, where working conditions were often cold and cramped and where the usual tools and materials were not readily available.

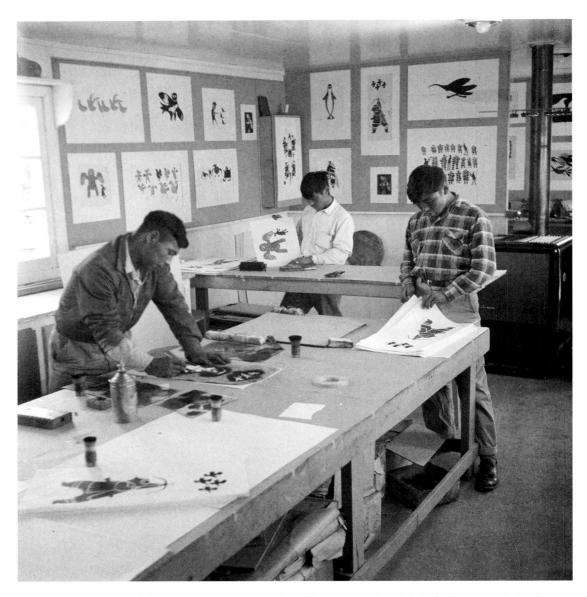

Printmakers at work in the studio in Kinngait, 1960. From left: Iyola Kingwatsiak, Lukta Qiatsuq, and Eegyvudluk Pootoogook. Source: Library and Archives Canada/Credit: Rosemary Gilliat/ National Film Board of Canada. Phototèque collection/PA-146511.

Most Inuit in the late 1950s and early 1960s still lived in far-flung camps, often great distances from the nearest village or town. In the vicinity of Kinngait, people made drawings mostly while in their camps and brought them to Kinngait when they came to town to trade. There, the printmakers and the arts advisor—at first Houston and later Terry Ryan—reviewed each drawing to determine whether or not it would work as a print.

By circumstance, then, a division of labor evolved between the graphic artists, many of whom were elderly, heavily involved in subsistence activities, or uninterested in printing their own work, and the printmakers, a handful of enthusiastic and talented young men who were willing to learn and experiment until they became expert at their craft.[11] As a result of this collaboration, the printers emerged as artists in their own right. As they gained experience, they made more and more decisions on their own when transforming a drawing into a print. Sometimes the adjustments and changes they made to a print were minor, and at other times, substantial. The success of the printmaking program and the printmakers' demand for images inspired many Inuit, especially women, to take up drawing. The opportunity gave women not only a new avenue for artistic expression but also economic independence.

After returning from Japan, Houston suggested that the artists and printmakers of the West Baffin Eskimo Co-operative sign their work using signature blocks written in syllabics, the system of writing introduced to the Inuit in the late nineteenth century. They readily adopted the practice, which was similar to that of Japanese printmakers, and from 1960 to 1974 each Kinngait print had both the printer's and the artist's "chops," or stamps, as well as an igloo "chop" representing the community of Kinngait.

The worldwide acceptance of the Inuit print as a valued art form could not have taken place without a climate that encouraged experimentation and allowed talented artists to hone their technical skills and expand their creativity. Such an environment was provided in Kinngait by the West Baffin Eskimo Co-operative (WBEC), which today is one of thirty-one such co-ops throughout Nunavut and the Northwest Territories. Its successful printmaking program was continued by Terry Ryan after James Houston left the Arctic in 1962.[12] Under Ryan's visionary and astute guid-

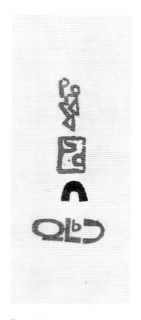

Detail from plate 1 illustrating the signature block found on early Kinngait stonecuts and stencils. The top symbol is the artist's name (Kenojuak Ashevak), and the next one is the printmaker's (Lukta Qiatsuq). The igloo symbol represents Kinngait. The lowermost symbol stands for the Canadian Eskimo Arts Council; it usually did not appear in the image area of a print. Detail of PM 62-3-10/40705. 98810025.

Inuktitut syllabics chart. Inuit artists often use the syllabic system of
writing to sign their prints, drawings, and sculptures. Some of them
incorporate syllabic texts in their
artworks as well.

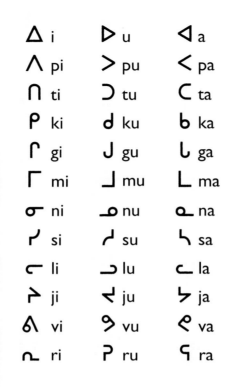

Δ i	▷ u	◁ a
Λ pi	＞ pu	＜ pa
∩ ti	⊃ tu	C ta
ᑭ ki	ᑯ ku	ᑲ ka
ᒋ gi	ᒍ gu	ᒐ ga
ᒥ mi	ᒧ mu	ᒪ ma
ᓂ ni	ᓄ nu	ᓇ na
ᓯ si	ᓱ su	ᓴ sa
ᓕ li	ᓗ lu	ᓚ la
ᔨ ji	ᔪ ju	ᔭ ja
ᕕ vi	ᕗ vu	ᕙ va
ᕆ ri	ᕈ ru	ᕋ ra

ance, first as the arts advisor and secretary to the board of directors and later as general manager of the co-op, Kinngait emerged as a leading arts center, paving the way for printmaking programs in other communities.

Today, in addition to the print studios, which are now known as Kinngait Studios, the WBEC operates a retail store, manages property rentals, and provides fuel delivery to the community. It markets the work of its artist members through Dorset Fine Arts, its sales outlet in Toronto. As has been the case since the beginning of the printmaking program, each annual release of Kinngait prints is published in an illustrated catalogue, with accompanying essays. The titles, formats, and publishers of the catalogues have varied over the years, but they are known collectively as the Cape Dorset print catalogues. Together they offer a wealth of information about individual artists and the history of Cape Dorset printmaking.

Contemporary Inuit art had already gained a large audience of collectors, exhibitors, and dealers by the time the Metropolitan Museum of Art in New York City included three Inuit sculptures in its 1970 exhibition *Masterpieces of Fifty Centuries,* which showcased the finest objects in the museum's collections. One of the three, portraying a seated woman with a child, was a piece that James Houston had received from the Inuit hunter Peesee Osuitok (1913–1979) in the winter of 1953–1954, in

return for a rifle.[13] During the more than four decades since that exhibition, Inuit art has received worldwide acclaim, and the work of several younger artists active today has gained recognition far beyond the specialized realm of indigenous art. It is no surprise that the book *Canadian Art: From Its Beginnings to 2000*, published in that millennium year, highlighted the works of thirty Inuit artists, both living and deceased.[14] Inuit sculpture, graphic arts, and, more recently, works in other media have become known and respected around the world.

The arts have developed and flourished not only in Nunavik and Nunavut, where most of the works in the Nash collection were made, but throughout the Canadian Arctic. In the western area, which is part of the Northwest Territories, residents of communities that developed out of missions and trading posts were encouraged to produce carvings early on. This area has become especially well known for its fine needlework, including wall hangings made from sealskin, decorated ceremonial clothing, and dolls dressed in Native garb. The community of Ulukhaktok (Holman) is widely recognized for its printmaking program, the only one in the western Arctic, which debuted in 1965 with a public exhibit and the sale of thirty-seven prints.[15] In addition to Kinngait, the other printmaking centers operating today in Nunavut are in Panniqtuuq (Pangnirtung) and Qamanittuaq (Baker Lake). Printmaking in Nunavik has been sporadic since the Puvirnituq (Povungnituk) print shop closed in 1989.

With greater access to formal training and increasing opportunities to attend workshops and festivals throughout Canada, Inuit artists today are exploring many new avenues of creativity and are working in a global context. Although stone is still the medium of choice for sculpture, as is evidenced by a recent Nunavut government initiative to evaluate carving-stone deposits, many artists are experimenting with other media and new methods. The result is a great spectrum of artistic activity, from jewelry making and metalwork to video art and filmmaking. Basketry, ceramics, and textile arts such as weaving, knitting, and doll making provide additional vehicles for individual expression that is grounded in tradition. Performing arts, including storytelling through songs, spoken word performances, and *kattajjaq,* the ancient art of Inuit throat singing, add yet another layer to the fabric of contemporary Inuit art today.

Since the first carvings appeared in galleries in southern Canada in the 1950s, many people have had something to say about contemporary Inuit art.[16] Early discussions among anthropologists, archaeologists, artists, government officials, and the viewing public centered on historical, aesthetic, and economic issues surrounding the art. Some partisans adhered to the romantic but unrealistic notion that Inuit works constituted an "untainted" and changeless art form. Other observers recognized that modern Inuit art was a recent development but feared that economic pressures and Western tastes would introduce too many foreign elements into it. Still other arguments revolved around standards to be used in evaluating the art. Some scholars called for an integrative approach, in which a work of art would be viewed through the lens of the artist's life experiences. Others wanted to base their judgments solely on formal and aesthetic considerations. Debates also arose over questions such as, What constitutes art and separates it from craft? Can a creation by someone without formal training, whose primary motivation is to generate income, be called art? And can art that has neither a utilitarian nor a magical or religious purpose be called Inuit?

Inuit art has long been admired, exhibited, and purchased around the world, and the work of several younger artists continues to receive critical acclaim. Nevertheless, some old expectations and stereotypes about art made by Inuit persist, especially with respect to the new wave of contemporary art created by a younger generation, whose reality is far removed from the experiences of their elders. Public pressure for sculptures made only from local materials and reflecting a former way of life still exists and can stifle creativity and experimentation. Many people would still rather view and buy a print of a hunting scene than one in which the artist expresses a moral dilemma or makes a political statement. But attitudes are slowly changing, among both the public and promoters of Inuit art. Today's artists, many of whom have received formal training, are expressing themselves in bold and unprecedented ways as they reflect on their present and past and look forward to the future.[17]

Nowadays, we can listen to the voices of the artists themselves through books, films, lectures, exhibits, and other avenues. The establishment of the Inuit Art Foundation in 1987 gave Inuit artists not only support in the form of training and

education programs, networking opportunities, and monetary assistance but also a vehicle for expressing their thoughts and concerns through the organization's publication, *Inuit Art Quarterly*.[18] Discussions of the present state and future directions of Inuit art remain vigorous, something James Houston—who in 1971 wrote that it is the stimulation gained from a lively debate and varying viewpoints that enables an art form to develop and thrive—would have liked.[19]

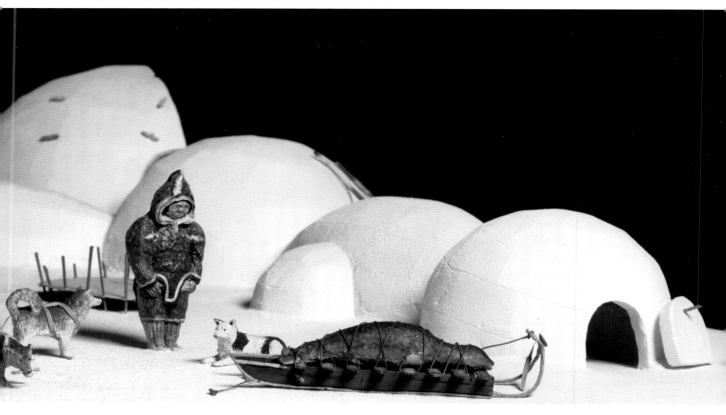

Detail of a Baffin Island Inuit winter house group diorama. PM 08-38-10/74478. 98830002.
Mark Craig, photographer.

The Peabody Museum and the Arctic

PEOPLES OF THE ARCTIC have played only a minor role in recent Peabody Museum history, but such was not the case in the decades immediately following the museum's founding by George Peabody in 1866. Peabody's expressed wish was for the museum to take as its primary objective the acquisition and preservation of archaeological and ethnological collections relating to the Native populations of the Americas.[20] In the museum's early decades, collections representing New World cultures and many others, for comparative purposes, grew with lightning speed through donation, purchase, and exchange with other institutions.

By the beginning of the twentieth century, northern peoples from Alaska to Greenland were well represented at the Peabody Museum in collections such as those of Lieutenant Robert E. Peary from Greenland, Captain James S. Mutch from Baffin Island, Jewell D. Sornborger from Labrador, and Captain Edward G. Fast and Edward W. Nelson from Alaska, the latter as part of a reciprocal arrangement with the Smithsonian Institution.[21] Indeed, the first book acquired by the Peabody

KAKITSOK, Pinnersok taiutilik,

Woodcut illustrating *Kaladlit Okalluktualliait*, a four-volume set of Inuit legends collected from throughout Greenland and issued between 1859 and 1863. In this scene, from the legend of Kakitsok, the hero responds to a challenge of strength by picking up the carcass of a narwhal and throwing it onto an ice field. The handwritten caption translates as "Kakitsok, with the nickname Pinersok (the handsome one)." Tozzer Library of the Harvard Library, SPEC.COLL. N.A.REL. K124, vol. 3.

Museum for its library, shortly after its founding, was a volume of Inuit legends titled *Kaladlit Okalluktualliait* (Greenlandic legends). This volume, identified on the flyleaf, in elegant handwriting, as the first book to be printed in Greenland, was presented to the museum in 1866 by Professor Paul A. Chadbourne of Williams College, who had received it from the governor of South Greenland in 1860.[22] Because the Peabody Museum served as the central office for the Department of Ethnology and Archaeology of the World's Columbian Exposition of 1893, it became a hub of activity related to anthropological work in the Americas around that time, including expeditions to the Arctic.[23]

Before the completion and opening of the Peabody Museum building in 1877, anthropological collections, including Arctic materials, were arranged first in cases in the anatomical laboratory in Harvard's Boylston Hall and later in a gallery in the Anatomical Museum. For several years after the opening of the new building, the Eskimo specimens formed part of a general ethnological exhibit in the Warren Gallery on the fourth floor, which also included specimens from British Columbia, the South

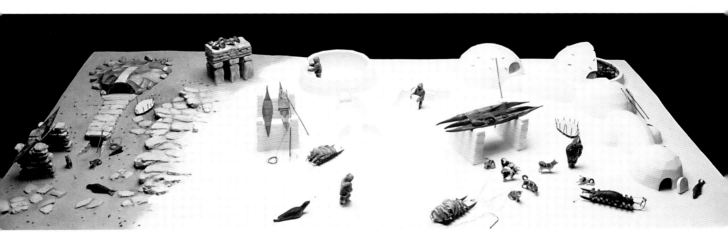

Diorama of a Baffin Island Inuit winter house group. Received by the Peabody Museum in 1908, this diorama was made by Samuel James Guernsey, whose gift for creating anthropological models of unusual accuracy and beauty eventually led to his receiving a full-time appointment with the museum. PM 08-38-10/74478. 98830008. Mark Craig, photographer.

Pacific, Africa, and the Ainu region of Japan, as well as wall and overhead exhibits of boats and canoes of various peoples and Eskimo sleds and kayaks.[24] It was not until 1902, when gallery space that had been granted temporarily to the Semitic Museum became available once again, that all the Native American exhibits, including those about the Eskimo, were brought together on the first two floors, arranged according to linguistic families in a way that would encourage instruction and comparison.[25]

The Peabody's wealth of objects from all over the world no doubt made an impression on the young Harvard student and fledgling collector Chauncey C. Nash, who would much later in life donate to the museum the collection featured in this book. Museum collections figured large in the teaching of anthropology at the time. Perhaps Nash knew the soon-to-be renowned Arctic explorer Vilhjalmur Stefansson, who,

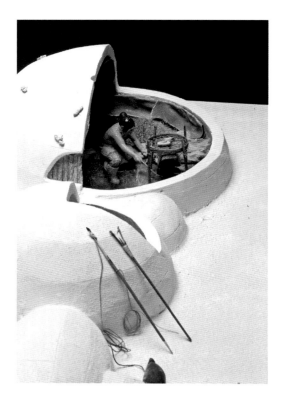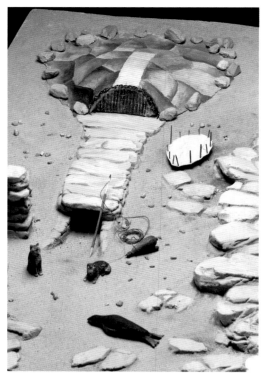

Details of Baffin Island Inuit winter house group diorama. PM 08-38-10/74478. Left: 98830003; right: 98830005. Mark Craig, photographer.

having changed his course of study from religion to anthropology, was a graduate student and teaching fellow in anthropology at Harvard during Nash's undergraduate days. Stefansson was already looked upon as something of an authority on the polar regions.[26] In 1913 he presented the museum with ethnological specimens from northwestern Canada and Alaska, which he obtained while serving as the ethnologist for the Anglo-American Polar Expedition. The late 1920s and early 1930s brought Stefansson into contact with Harvard again, as a collaborator in a study of the relationship of Eskimo skeletal characteristics to diet.[27] Archaeological excavations

conducted at Point Barrow, Alaska, in 1951–1953, under the directorship of graduate student Wilbert K. Carter—although the results were never written up or published—added further to the Arctic collections of the Peabody Museum.[28]

As collections in the Peabody Museum grew and it reconfigured its space to accommodate both artifacts and people, a gradual shift in thinking was emerging in the United States and Europe concerning tribal, or "primitive," art. In the nineteenth and early part of the twentieth century the perceived and accepted purpose of collecting and exhibiting objects from "primitive" cultures was scientific study only; their proper place was a museum devoted to supporting such study. It was the Brooklyn Museum, a fine arts institution, that paved the way for change in 1923 with an exhibit of African art. Similar exhibits followed in art museums in Paris, Brussels, and Cleveland. The first collaboration between an art museum and an anthropology museum in the Boston area took place in 1934 at Harvard's Fogg Art Museum with a small exhibition of Oceanic and African works chosen from the collections of the Peabody Museum, where they had previously been presented primarily in a scientific context.[29]

In 1941, twelve years after its founding, New York's Museum of Modern Art (MOMA) unveiled the pivotal exhibition *Indian Art of the United States,* under the direction of René d'Harnoncourt, general manager of the Indian Arts and Crafts Board of the Department of the Interior. Although MOMA had mounted several other exhibitions of "primitive" art before 1941, this one differed radically in scope and presentation. It was overwhelmingly popular, not only with the public but also with many artists, and it went far in demonstrating that universal aestheticism and cultural specificity in Native American art did not have to be mutually exclusive.[30]

By the late 1950s, great strides had been made in bridging the divide between art and ethnography, not least with the opening of the Museum of Primitive Art in New York in 1957. Nevertheless, the announcement in 1958 of a joint exhibit titled *Masterpieces of Primitive Art* by the Museum of Fine Arts, Boston, and the Peabody Museum at Harvard demanded attention, both in the media and in the museum world. The driving force behind this collaboration was the director of the Peabody Museum, John Otis Brew. Having considered such a project previously, Brew was newly

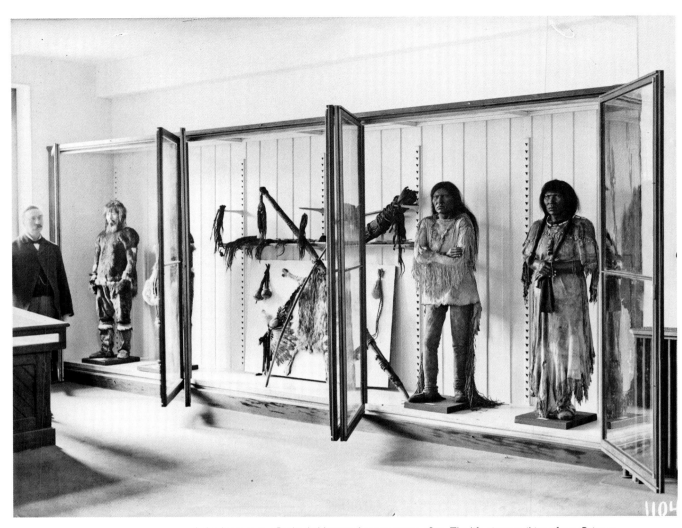

A display case in a Peabody Museum lecture room, 1893. The life-size manikins of two Paiutes and an Eskimo (at far left) are dressed in authentic clothing from the Peabody collections. PM 2004.24.1104. 130440004.

motivated by the museum's association with the distinguished photographer Eliot Elisofon and the enthusiastic response of Perry T. Rathbone, director of the Museum of Fine Arts, Boston.[31]

Brew wrote enthusiastically in his annual report for that year about the success of the exhibit and plans for a permanent cooperative arrangement between the two institutions. Works of art from the Peabody Museum would be exhibited to a different and larger audience at the Museum of Fine Arts through rotating exhibits in a room permanently assigned to that purpose, with a major exhibition mounted every three years or so.[32] This arrangement lasted only about a decade, but it highlights Brew's respect and appreciation for the artistic expressions of all cultures and his interest and involvement in the art collections at the Peabody Museum. It was probably his enthusiasm that encouraged and motivated his friend Chauncey Nash so greatly in his efforts to collect Inuit art.

Chauncey C. Nash in Plymouth, Massachusetts, 1909. Courtesy Chandler Gifford Jr.

CHAUNCEY C. NASH

Collector, Scholar, Stockbroker

CHAUNCEY CUSHING NASH (1884–1968) was born in Boston, Massachusetts, to Herbert and Mary Chaffee (Baldwin) Nash.[33] One of six children, he attended the Boston Latin School and the Volkmann School before entering Harvard College with the class of 1907. His father was an importer of teas, having joined the firm started by his father, Israel Nash, after studying the tea trade for two years in Shanghai, China. When Israel retired, Herbert continued the business, together with a cousin. At the time Chauncey Nash entered Harvard, the family was living on Newbury Street in Boston.

Chauncey Nash traced his New England roots back to the mid–seventeenth century, when his ancestor Walter Briggs arrived in Scituate, Massachusetts, from Suffolk, England. Among Nash's forebears was his great, great, great–grandfather James Briggs Jr., the first in a distinguished line of shipbuilders working out of Briggs Yard on the North River in Plymouth County for nearly a century. It was Briggs who in

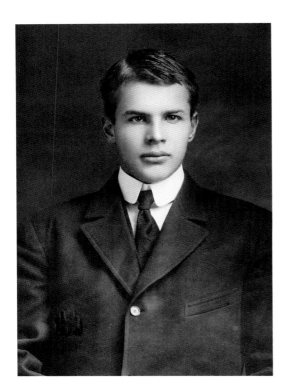

Chauncey C. Nash, 1907. Harvard University Archives, call no. HUD 307.505, Box 15, no. 467.

1773 built the *Columbia*, the first vessel to circumnavigate the globe under the American flag. The same vessel was used to explore the Columbia River in the Pacific Northwest; the river was named for the ship by her captain, Robert Gray. Nash could also count among his ancestors veterans of several historic wars, including King Philip's War and the Revolutionary War, as well as James Otis, a leading champion of colonial rights before the American Revolution.

Chauncey Nash was a collector from early childhood. He sought out interesting objects in many areas, a hobby he continued throughout his lifetime. During his student days at Harvard, he was a member of the Institute of 1770, the Hasty Pudding Club, and the Harvard Memorial Society, whose object was to promote interest in Harvard history and traditions.[34] He took several courses in anthropology, including general anthropology, North American archaeology and ethnology, and Mexican prehistory, in the relatively new Department of Anthropology.[35] Anthropology as a formal program of study had been instituted at Harvard only in 1890, more than two decades after the founding of the Peabody Museum in 1866.[36] After completing his coursework for a Harvard degree in three and a half years, Nash, together with his classmate William Bowditch Long, went on an extended hunting trip to Florida and North Carolina before gradu-ation. In 1909, following brief periods of employment with a Boston stock exchange firm and a bond house, he established, in partnership with William Long, the stock brokerage and investment firm of Long and Nash, beginning a career that lasted almost sixty years.

In 1913 Chauncey Nash married Susan Higginson Long, the sister of his classmate, business partner, and hunting companion, Bill Long. In Milton, Massachusetts, to which Nash later moved with his wife and two children, he began raising prize-winning poultry and English setters and cultivating in earnest his interest in early American furniture, especially that of the Pilgrim period, and other antiquarian and

historical subjects pertaining to North America. Many of his most important and active society memberships reflected his burgeoning interest in collecting, preserving, and organizing American antiquities and knowledge about them. Of special note are his memberships in the Walpole Society, the American Antiquarian Society, the Society for the Preservation of New England Antiquities (now known as Historic New England), of which he was a trustee, and the Club of Odd Volumes, a private social club of bibliophiles founded in 1887 in Boston. Nash served as secretary of the Walpole Society for twenty-three years (1939–1962). The society's tribute to him and his many contributions sums up eloquently the kind of person Chauncey Nash was:

> Upon him [Chauncey Cushing Nash] . . . has rested the responsibility for the continuance of the Society in health and vigor and unchanged purpose. No man ever carried through a voluntary task with greater devotion and greater effectiveness. No man ever exercised supreme power over a group of individualists with greater kindness and wisdom. None of the present members can imagine being without the guidance of one who though oldest in years of membership remains as zealous for the Society's well being and as effective in promoting it as when he first assumed the burden of its affairs. By having made himself so completely our servant, he has become our master, our modest, self-effacing master, affectionately regarded by each of us throughout the years.[37]

Nash not only pursued his eclectic interests with determination and vigor but also readily shared his knowledge and expertise with others. Through his collecting and his continuous study of subjects related to Americana, he became a recognized authority on early American furniture, together with his wife, Susan, an expert in her own right on the decorative arts and historic preservation. Photographs of and information about their rare colonial furniture, including a cradle that reputedly had belonged to the family of Samuel Fuller, the physician of the *Mayflower,* played a prominent role in Wallace Nutting's seminal work *Furniture of the Pilgrim Century*.[38] Along with a handful of other Boston-area collectors of early American furniture, Nash helped furnish some of the period rooms in the Museum of Fine Arts, Boston. He shared his interest

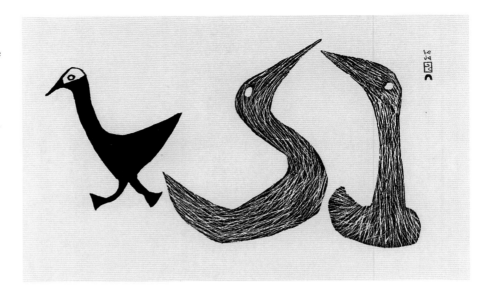

Qabavoak Qatsiya (b. 1942), *Two Birds, One Duck*. Chauncey Nash's delight in birds, hunting, and nature may have influenced his decision to purchase prints like this one. Stencil printed by Lukta Qiatsuq, Kinngait (Cape Dorset), 1963. 29/50. 50.1 × 62.6 cm. PM 64-34-10/ 43983. 98810032.

in the history of early American publishing through his monograph *John Warner Barber and His Books*, which dealt with the work of that fascinating nineteenth-century writer, illustrator, and engraver.[39]

Nash's close involvement with historical and antiquarian societies, his lifelong love of the outdoors, especially game shooting and bird watching, and his regular cross-country visits to his son and daughter, who lived in California most of their adult lives, made for an active and interesting life. Chandler Gifford, Nash's nephew, recalls how Henry DuPont, one of the then thirty-five members of the Walpole Society, would bring his private railroad car to Boston to pick up his uncle and other members for a journey to Winterthur or some other historic site.[40] Nash wrote for the fiftieth anniversary report of his Harvard class that, since leaving college, he had been moose hunting in New Brunswick and duck shooting in various states. In his class notes five years later he talked about birding expeditions with members of the Massachusetts Audubon Society, as well as trips to California and Churchill, Manitoba. For health reasons, his plans to go even farther north never materialized.

In addition to his collection of Inuit art, Nash presented Harvard with many other gifts over the years, including books, manuscripts, drawings, illustrations, letters, posters, and pre-Revolutionary coins, all reflecting his multifaceted interests. It is not surprising that fifty-five years after graduating from Harvard, Chauncey Nash chose to share with his classmates his enthusiasm for the rare birds he had seen rather than news of his business years. According to those who knew him, he was an unassuming, understated, generous man, ever curious about the world around him. His prized collection of Inuit art forms but a small part of his legacy.

Interior of the Eskimo Museum in Churchill, Manitoba, late 1950s. The museum was one of the first places where Chauncey Nash discovered Inuit sculpture. Courtesy Eskimo Museum and the Diocese of Churchill-Hudson Bay.

Building the Collection

AS FORTUNE HAD IT, Chauncey Nash started collecting Inuit carvings in 1959, just two years after James Houston introduced the art of printmaking in Kinngait (Cape Dorset). Nash acquired works in both media between 1959 and 1967 and donated 60 prints and 210 sculptures to the Peabody Museum. The museum therefore holds not only a rich collection of early contemporary Inuit sculpture but also many of the earliest prints by women and men who helped propel Inuit art toward the stature and esteem in which it is held today.

Collections often tell as much about the collector as about the cultural traditions from which the objects derive. Among Chauncey Nash's many interests, as far back as his childhood, were nature and wildlife. It was his interest in bird migration that in 1958 led him to Churchill, Manitoba, on the southwestern shore of Hudson Bay, where he first saw Inuit sculpture at the Hudson's Bay Company store and the Eskimo Museum, which had been established by the Roman Catholic mission in Churchill.

Eliya Pootoogook (b. 1943), *Hunter's Implements*. Collected by the hunting enthusiast Chauncey Nash, this print depicts a kayak and its paddle, a three-pronged fish spear, and a sealskin float with the blow piece used for inflating it. The float prevented the body of an animal such as a seal from sinking after it was killed at sea. Stonecut printed by Iyola Kingwatsiak, Kinngait (Cape Dorset), 1966. 11/50. 50.5 × 63.8 cm. PM 967-72-10/45943. 99810019.

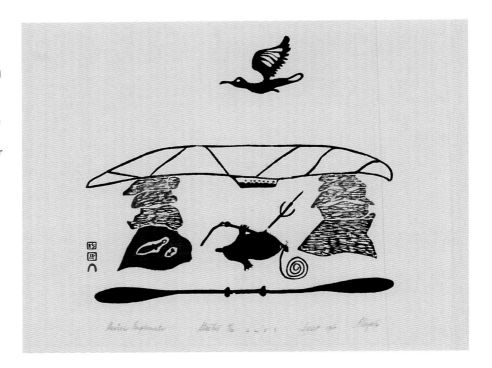

This trip no doubt fired Nash's enthusiasm and led him—building on his long-standing interest in the Native peoples of the American Southwest—on another journey of discovery for the last decade of his life. According to Chandler Gifford, once his uncle discovered a new area of interest, there was no stopping him, and he pursued it with a zeal hard to surpass. Nash's lifelong enthusiasm for nature, animals, and hunting helps explain why the art of a culture so closely aligned with the natural world appealed to him, and it helps account for the collection's preponderance of images of birds, animals, and subjects related to hunting.

In 1959, about a year after he visited Churchill, Nash began donating Inuit sculptures to the Peabody Museum. At first he purchased sculptures from the Hudson's Bay Company in Churchill, but over time he came to rely increasingly on the services

of Brother Jacques Volant, a member of the Missionary Oblates of Mary Immaculate (OMI) who had served since 1948 as curator of the Eskimo Museum, a post he held for thirty-eight years. A large part of the success of this small, highly regarded museum is attributed to the dedication of Brother Volant. His contributions were recognized in 1979 with an honorary doctorate from the University of Manitoba and in 1981 with an Award of Merit from the Canadian Museum Association.[41]

In order to fulfill his objective for the Eskimo Museum, which was to depict traditional Inuit life through carvings and other objects of ethnographic interest, Volant selected pieces carefully from among those sent to him by fellow missionaries throughout Nunavut and Nunavik. Nash and Volant corresponded frequently concerning the missionary's efforts to procure carvings and other items, not only for the Eskimo Museum and the growing number of tourists visiting the area but also for Nash. Often Nash's requests for carvings were specific as to size, material, quality, subject matter, and even community of origin. It appears that he was striving for a balanced collection, as is evidenced by requests such as one for a larger owl than the one he had received previously and the statement that he wanted no more stone carvings, only ivory ones, unless there was something unique about a particular piece made from stone. Nash was always quick to point out in his letters that he would be donating the majority of the sculptures to the Peabody Museum, keeping only a few for himself. Although Nash never returned to Churchill, the letters between the two men were often friendly as they shared news about people they both knew and information about books they had read.

Nash's introduction to Inuit printmaking took place not in the Canadian Arctic but right at home in Boston. One of the first presentations of Kinngait prints in the Boston area, if not the very first, appears to have taken place at Boris Mirski's art gallery on Newbury Street, which was known for showing and selling both modern and non-Western art. In October 1960, J. O. Brew, director of the Peabody Museum, met there with representatives from the Canadian consulate and the Canadian Department of Northern Affairs, who showed him a selection of prints and gave him a brief overview of the techniques used to make them, their pricing, and the story

of their development. Brew found the prints distinctive and striking. He alerted the director of exhibits at the Boston Museum of Science to this new art form, and the museum mounted a small exhibit of Inuit graphic arts the following March.[42] Chauncey Nash attended the opening of the exhibit, and I believe it was there that he purchased the first prints he donated to the Peabody Museum. Because marketing and networks of distribution for Kinngait prints had already been formalized by this time, he was able to obtain subsequent prints through U.S. dealers.

No doubt many factors went into Nash's decision to donate so many pieces of Inuit art to the Peabody Museum, something he continued to do until shortly before his death in 1968. Among those factors were probably his student coursework in anthropology and his social and family connections to the museum. For example, his wife, Susan, was related to Charles Pickering Bowditch, a longtime associate of the Peabody as a trustee, faculty member, and benefactor. Certainly the encouragement and interest of Nash's friend J. O. Brew motivated him in his collecting efforts. But probably the foremost reason, according to his nephew Chandler Gifford, was Nash's devotion to Harvard itself and the confidence he had in Harvard as an institution. Clearly Nash remained loyal to the university throughout his life, as his many donations and his enthusiastic involvement in class reunions testify.

Nash's donations of Inuit art, spanning the years between 1959 and 1967, coincided with the ten-year period of close collaboration between the Peabody Museum and the Museum of Fine Arts, Boston (MFA). Although there is no indication that these works were ever displayed as a group at the MFA during this time, they were exhibited in Boston for eleven months in 1962 at the Club of Odd Volumes, of which Brew and Nash were both members. Beekman H. Pool, historian, traveler, and author, presented a talk at the club on contemporary Inuit art and life, in conjunction with the exhibit. The Club of Odd Volumes subsequently published Pool's remarks, together with photographs of prints and sculptures from the collection, under the title *The Chauncey C. Nash Collection: Contemporary Canadian Eskimo Art*.[43]

The Nash collection garnered considerable interest in the 1960s and 1970s, and museum records show loans of portions of the collection to other institutions, such as

Brother Jacques Volant, longtime curator of the Eskimo Museum in Churchill, Manitoba, late 1960s. Courtesy Eskimo Museum and the Diocese of Churchill-Hudson Bay.

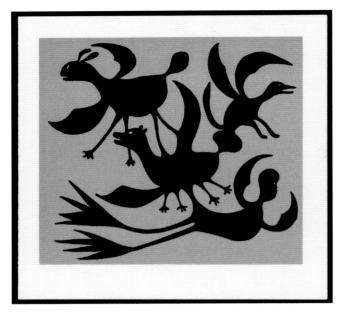

"Night Spirits," a stone-cut print, by Kenayuak, 1960.
Cape Dorset, Baffin Island, Canada.

Invitation to a talk on Inuit art sponsored by the Club of Odd Volumes, January 17, 1962. The talk was illustrated with an exhibition of prints and sculptures donated to the Peabody Museum by Chauncey Nash. The image on the front of the invitation is Kenojuak Ashevak's *Night Spirits*, 1960, PM 61-22-10/39045. Houghton Library, Harvard University, AC85.C6272.Zzx (1953–1972) = Box 3 FOLDER 1962.

❀ The regular monthly meeting of the Club of Odd Volumes will be held at the Club House, 77 Mount Vernon Street, Boston, on Wednesday evening, 17 January 1962.

❀ Supper will be served at 6:30 o'clock.

❀ Immediately following supper, Mr. Beekman Pool will speak to us about new horizons in Eskimo art, illustrating his remarks with an exhibition of Eskimo sculptures and prints from the collection which Mr. Chauncey C. Nash has given to the Peabody Museum of Archaeology and Ethnology, Harvard University, Cambridge.

DAVID B. LITTLE, *Clerk*

the Concord (Massachusetts) Free Public Library and the Peabody Museum in Salem, Massachusetts (now the Peabody Essex Museum). Museum records also indicate that items from the collection were displayed at Harvard's Peabody Museum in 1971 in a lobby exhibit entitled *Eskimos and Their Animals* and again in an exhibit of Inuit art in 1976. Brew mentioned using pieces from the collection, as well as films on Inuit art, in his classes on "primitive" technology.

Fortunately for researchers, Nash donated not only his collection of prints and sculptures to the Peabody Museum but also copies of his correspondence with Brew and the people who provided him with works of art. It is clear from these letters that Nash and Brew worked together closely to build the collection, so that it reflects not only Nash's ideas and opinions but also Brew's suggestions and requests.[44] The end result is a collection of prints and sculptures that represents one of the most vibrant and experimental periods in the history of contemporary Inuit art.

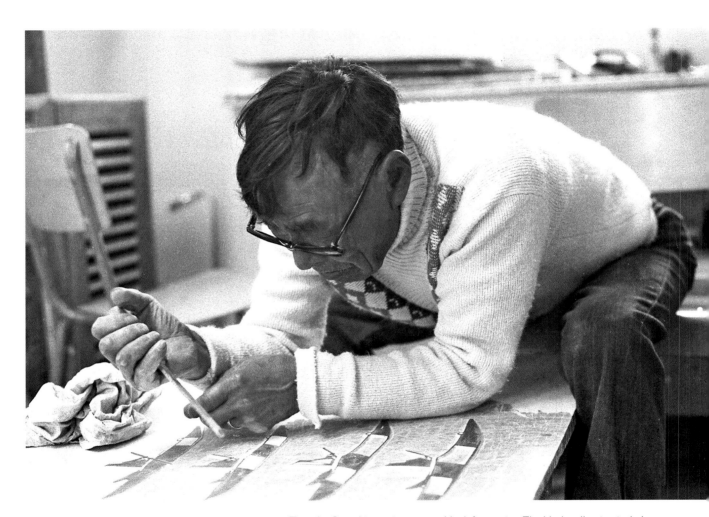

Timothy Ottochie cutting a stone block for a print. The Nash collection includes one of Ottochie's early engravings. Photograph: Tessa Macintosh.

The Chauncey C. Nash Collection of Prints and Sculptures

THE INTIMATE RELATIONSHIP that the Inuit have always had with their environment is evident not only in their ancient stories and legends, which have been passed down through generations, but also in their art. A fusion of the earthly with the spiritual, and of the human world with the animal world, is an identifying feature of many works. The prints and sculptures in the Chauncey C. Nash collection blend mythology, everyday life, personal experience, memory, oral history, folklore, and imagination. The subjects of both prints and sculptures range from relatively straightforward depictions of birds and animals; human forms, faces, and family groups; and camp and community activities (pl. 12) to the world of spirits and shamans with its wealth of myths and legends. An especially popular subject in Inuit art is the sea goddess (pl. 11), who is known by various names, including Sedna, Taleelayuk, Aviliayok, and Nuliayuk. Although versions of her story vary from region to region, she was universally thought to be the guardian of sea mammals and the spirit responsible for success

in hunting. The connection of the human world to the animal world was strong, and the boundaries were not always distinguishable.

Making art has been an important vehicle of survival for many Inuit individuals and communities, on several levels. Not only has it provided an important source of income in an ever-growing cash economy, but it has also helped many Inuit to survive emotionally during times of stress, hardship, and change.[45] Referring to another level of survival, Maria von Finckenstein, an art historian and former curator of Inuit art at the Canadian Museum of Civilization, wrote that the thousands of images created by Inuit themselves—not the reports produced by anthropologists and missionaries— were what helped keep Inuit culture alive.[46] In his introduction to the 1976 Cape Dorset print catalogue, Kananginak Pootoogook stated, "Our art helps us to understand each other. Our art will help us not to forget how our ancestors lived, for we do not live that same way today."[47]

But as important as representation of Inuit life and culture is in many of these works, so are purely stylistic and aesthetic elements, as well as personal preference, and these are what distinguish the works of one artist from those of another. A quick look at some of the artists whose work Chauncey Nash collected offers examples. Kiakshuk, who was already in his seventies when he began to draw, was notable for his graphic representations of traditional Inuit life and thought. Pitseolak, too, drew the old ways, as well as "monsters" that she had never seen but only heard about. Pudlo explored all subjects that fascinated him, from moments in daily life to the onslaught of modern technology. Kenojuak, one of the most famous artists represented in the collection, is known more for her emphasis on formal experimentation and for creating images that are visually pleasing than for representing either mythology or real life.

In their book *Cape Dorset Sculpture*, Derek Norton and Nigel Reading wrote about the development of individual styles and of the way Inuit art symbolizes rather than illustrates Inuit culture.[48] Although works in the Nash collection come from the early years of the contemporary period in Inuit art, when artists' subjects may have revolved more around "the old ways" than they do today, individual style and preference are nevertheless paramount and inform both prints and sculptures in the collection.

It has been said that in the early years Inuit artists drew what they thought outsiders wanted to see. But although contemporary Inuit art has always been produced primarily for a non–Inuit art market, it continues to speak to a dual audience today. Janet Catherine Berlo, an art historian and an authority on Native North American art, has suggested that Inuit art is like a two-way mirror, reflecting the Inuit as active participants in a changing social drama even as it informs a foreign audience of the contradictions between the traditional and modern inherent in the drama.[49] The "mirror" of art helps the Inuit to define their reality and reaffirm their identity while showing other viewers not only what they want and expect to see about the Inuit world but also a slice of their own world.

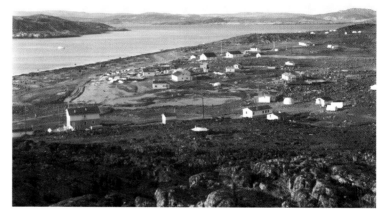

Kinngait (Cape Dorset), Nunavut, 1960. Source: Library and Archives Canada/Credit: J. Connor and M. McConnell/National Film Board of Canada. Still Photography Division/ e006609567.

PRINTS IN THE NASH COLLECTION

With the exception of the earliest experimental set of Kinngait prints, which was made in 1957 and 1958 and sold through the Hudson's Bay Company in Winnipeg, catalogued collections of limited–edition Kinngait prints have been released annually by Kinngait Studios, the print studios of the West Baffin Eskimo Co-operative. More than half of the sixty prints in the Nash collection came from the 1960 and 1961 releases, and the rest from the 1962, the 1963, the combined 1964–1965, and the 1966 catalogues. The earliest prints were made using either the stonecut or the stencil technique, or sometimes a combination of the two. By the time the 1962 prints were released, the printmakers had added engraving to their corpus of methods, and most

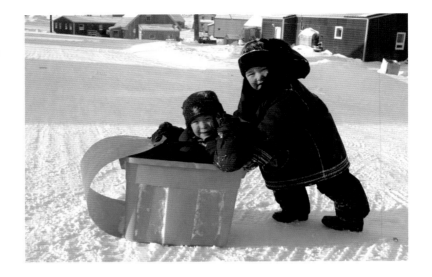

Numa Ottokie pushes Charlie Kinguatsiak in a makeshift sled. Kinngait (Cape Dorset), Nunavut, 2004. Photograph by William Ritchie.

of the prints in the 1962 catalogue, as well as more than half in the 1963 one, were engravings. The 1975 release saw the fruits of further experimentation in the form of lithographs. It was such experimentation with techniques that led to the array of prints one sees today, with their broad spectrum of colors and deep expressiveness.

As Jean Blodgett pointed out in *In Cape Dorset We Do It This Way*, her survey and history of the West Baffin Eskimo Co-operative and the first three decades of Kinngait printmaking, artists submitted many more drawings to the print shop than could possibly have been made into prints.[51] The cooperative's archive of drawings became an important body of work in its own right. Being familiar solely with the drawings of an artist that were made into prints provides only partial knowledge of the work of that artist. Moreover, it was not uncommon, especially in the early years, for the printmaker to rearrange a drawing or use only part of it in a print, thus modifying the artist's original work by combining the ideas of both artist and printer. Yet the important role of the printmaker in many artworks has often been overlooked.

The Peabody Museum is fortunate to have, in the Nash collection, the earliest work of several of the best known and most highly esteemed Inuit graphic artists.

PRINTMAKING TECHNIQUES

STONECUTS. In a stonecut print, a design is transferred to the surface of a flat, polished stone, and the areas that are not to be printed are cut out.[50] The raised areas of the image are inked, and a sheet of paper is placed on the surface. The image is then transferred to the paper through pressure applied by rubbing with a circular tool called a baren or with a metal spoon. This is known as the "relief method" of printing.

STENCILS. In a stencil, the areas to be inked are cut from paper that has been saturated with melted wax and allowed to dry. The stencil is then placed on top of a blank sheet of paper and ink is applied to it with a special brush, leaving the design on the paper. Stenciling can be combined with the stonecut technique by adding it as a second step after the stonecut is printed.

ETCHINGS AND ENGRAVINGS. In etching and engraving, the image is incised into a copper plate, which is then inked and wiped clean, leaving ink only in the incised lines. The pressure of the printing press forces paper into the lines to pick up the ink. Despite some differences between the two processes, artists in both cases work directly on the plate. Etching and engraving are known as intaglio methods of printing.

LITHOGRAPHS. Lithographs are printed from the surface of a stone or metal plate. The artist draws directly on the stone or plate with a greasy medium such as a lithographic crayon. The stone or plate is then put through a series of chemical processes that, through the mutual repulsion of oil and water, enable it to receive ink in the greasy areas. The ink is then transferred to paper.

OTHER PRINTMAKING TECHNIQUES that have been used in Kinngait over the years include woodcut, linocut, and serigraphy. Woodcuts and linocuts use a relief method of printing, similar to stonecuts, whereas serigraphy is a stenciling technique applied to fabric.

Usually sixty prints are created from a single printing matrix, whatever its type, and from these an edition of fifty is chosen. The matrix is then cancelled. In the case of stonecuts and lithographs, canceling consists of chiseling or grinding the image off, so the stone can be used repeatedly.

The kind of paper used for Inuit prints is determined by the printmaking method. Handmade Japanese papers, with their long fibers, are especially strong and are ideal for stonecuts. Intaglio methods of printing, such as etching and engraving, as well as lithography, require paper that remains strong when damp. French mold–made papers are commonly used for these prints.

Terry Ryan with a group of artists inside the Kinngait printing studio, 1961. Left to right, front: Parr, Kiakshuk, Pitseolak Ashoona, Kenojuak Ashevak, Eegyvadluk Ragee, Lucy Qinnuayuak, Napachie Pootoogook, Pudlo Pudlat. Rear: Terry Ryan. © Government of Canada. Reproduced with the permission of the Minister of Public Works and Government Services Canada (2010). Source: Library and Archives Canada/Credit: B. Korda/National Film Board of Canada. Photothèque collection/e002265684.

Particularly noteworthy are the works of two artists whose engagement in their art and community spanned five decades, from the earliest days of Inuit printmaking into the twenty-first century. One has only to look through Kinngait print release catalogues over the years or scan issues of *Inuit Art Quarterly* to understand just how extensive has been the artistic output of Kenojuak Ashevak (b. 1927) and Kananginak Pootoogook (1935–2010).

Kenojuak, a remarkable woman whose outstanding artistic contributions have earned her many awards and honors over the years, was one of the first women to participate in Kinngait arts projects. She was also the first woman in the community to start drawing. Kenojuak's images can be seen not only in museums and galleries around the world but also on postage stamps, coins, calendars, and buildings. Appleby College, west of Toronto, for example, commissioned her to design a large stained-glass window on its campus. Among the many honors accorded to Kenojuak have been commissions for works commemorating the signing of the Inuit Land Claim Agreement in Principle in 1990 and the signing of the Final Agreement in 1994. One of her artworks is represented on a Canadian twenty-five cent piece that was released to celebrate Inuit art and culture on the eve of the formation of Nunavut as a separate, self-governing Canadian territory on April 1, 1999. Kenojuak is a member of the Royal Canadian Academy of Arts and a Companion in the Order of Canada. Although she is known the world over primarily for her prints, she has worked in many media and gained respect for her sculptures as well. She has traveled widely in her role as an ambassador for Inuit art and a spokesperson for Inuit women.

Kenojuak Ashevak, 2005.
Photograph by William Ritchie.

Kenojuak spent her early years living a traditional camp life on South Baffin Island, traveling from camp to camp. The availability of game determined the length of the family group's stay at any particular campsite. When local food sources failed, the ability of the Inuit to change campsites quickly, sometimes over great distances, became of utmost importance. Moving camp could involve returning to a previously used spot or exploring new territory.

It was in the late 1950s that both Kenojuak and her husband, Johnniebo, began to experiment with drawing and carving. Her drawings held immediate appeal, and with the initial encouragement of James Houston, she embarked on an artistic career that has spanned half a century.

Kenojuak's early work is represented in the Nash collection by four prints. Three are stonecuts—*The Return of the Sun* (pl. 1), *Night Spirits* (see illustration on p. 38), and *Complex of Birds* (not illustrated)—and one is a linocut (*Bird Humans*, on the front cover). All four reflect characteristics that have come to be associated with Kenojuak's work: a blending of the real with the fantastic, an emphasis on form and design rather than on representational or narrative content, and a focus on birds. Kenojuak likes birds and draws them frequently, adding them even when they are not the primary subject of a work or fusing their characteristics with those of mythical beings. She has often said that her main goal is to produce a pleasing image. Toward that end she uses her vivid imagination to develop in a drawing an idea that might not be resolved until she is finished. As Jean Blodgett observed in her 1985 book about Kenojuak and her art, aesthetic considerations far outweigh subject matter for Kenojuak, and it is her formal experimentation and unique treatment of any subject that make her work stand out.[52]

Like Kenojuak, Kananginak spent his early years in camps on South Baffin Island, primarily at Ikirisaq, where his father, Joseph Pootoogook (1887–1958), was the highly respected camp leader. When Joseph Pootoogook's health began to fail in the late 1950s, the entire family moved to Kinngait. James Houston credited Joseph Pootoogook with much of the early acceptance of printmaking by the Kinngait Inuit. Because of his leadership role, his drawings were among the first to be translated into prints, and the stamp of approval accorded to his work was carried over to the program as a whole.[53]

Kananginak became involved with the Kinngait printmaking program as part of a small group of young men whom Houston hired to transform drawings submitted by members of the community, including several by his father, into prints. In short order, Kananginak, who also helped establish the West Baffin Eskimo Co-operative and served as its first president, began submitting his own drawings to the co-op. Several hundred of his drawings have been translated into print media including stonecuts, stencils, lithographs, engravings, and etchings. Kananginak was also a highly regarded sculptor and a member of the Royal Canadian Academy of the Arts.

Kananginak's immediate and extended family is well represented in the Nash collection through works by his father; mother, Ningeookaluk (1889–1962); brother Eegyvudluk (1931–1999), the printer of several works in the collection; sisters-in-law Napachie (1938–2002) and Sarni (1922–2003); cousin Mary Pitseolak (b. 1931), the daughter of Joseph Pootoogook's brother, Peter Pitseolak; and nephew Eliya (b. 1943). Napachie, who was married to Eegyvudluk, was the daughter of the esteemed artist Pitseolak Ashoona (1904–1983), who is also represented in the collection. Sarni's broth-

Kananginak Pootoogook, 2010. Photograph by William Ritchie.

er, Pauta Saila (1916–2009), best known for his dancing bear sculptures, played a major role in the early days of the printmaking program and, until his death at the age of ninety-three, was the oldest resident of Kinngait. His 1964 stonecut *Owl* (see p. 112) is part of the Nash collection. Just this brief glance at the artistic activity of a single family gives some idea of Kinngait's opulence of talent and artistic involvement.

Although the Nash collection includes only one print by Kananginak (*Summer Caribou*, pl. 2), it is an excellent example of his early style, philosophy, choice of subject matter, and approach to drawing. From early childhood Kananginak was a close observer of nature and Arctic wildlife, and he developed great respect for all animals. His attention to detail is reflected not only in his realistic images of birds and mammals but also in his many depictions of daily life and hunting. Kananginak was always interested in documenting Inuit life and traditions for future generations, and in his last decade or so he placed special emphasis in his art on social and cultural change as a result of contact with outsiders.[54] Kananginak's death in 2010 not only meant the loss of an outstanding artist and inspirational leader but also marked the end of an era.

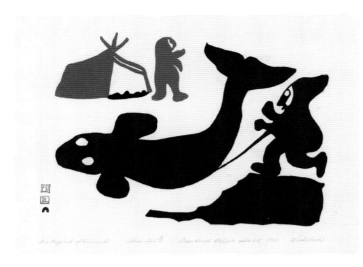

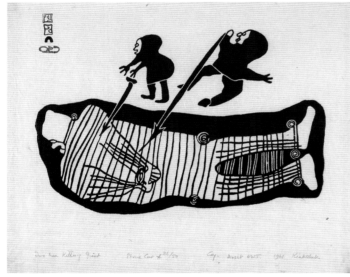

Kiakshuk (1886–1966), *The Legend of Lumiuk*. Stonecut printed by Iyola Kingwatsiak and Lukta Qiatsuq, Kinngait (Cape Dorset), 1960. 18/50. 38.2 × 53.4 cm. PM 61-22-10/39049. 98810021.

Kiakshuk (1886–1966), *Two Men Killing Giant*. Stonecut printed by Lukta Qiatsuq, Kinngait (Cape Dorset), 1961. 36/50. 37.2 × 45.9 cm. PM 64-34-10/43986. 98810033.

More than one-fifth of the prints in the Nash collection are by Kiakshuk (1886–1966), a hunter who, during his relatively short artistic career, played a pivotal role in the development of the Kinngait graphic arts program. Already in his seventies when he began to draw at the encouragement of James Houston, he depicted what he knew best: hunting, camp life, and survival. He had an intimate knowledge of the land and of the sea animals that inhabited his harsh environment. Pitseolak Ashoona, his younger cousin, stated in her 1971 autobiography, *Pitseolak: Pictures Out of My Life*, that Kiakshuk did "real Eskimo drawings" because he was an old man and had grown up with traditional ways.[55]

Kiakshuk contributed more than fifty prints to the Kinngait graphics collection. Although most of those in the Nash group are stonecuts, once engraving was introduced in 1962 Kiakshuk devoted himself almost exclusively to that medium, in which he could incise the image directly onto the copper plate. In his precise drawings of a vanishing way of life, Kiakshuk portrayed objects of the hunt on both land and sea, scenes from daily life (*Summer Camp Scene*, pl. 3), and shamans, spirits, and characters from legends. Kiakshuk, who was reputed to be a shaman, was known as a great storyteller. In the 1958 film *The Living Stone*, produced by the National Film Board of Canada, he recounted the legend of the sea goddess, Sedna (see pl. 11 and the illustrations on p. 98). Several

of the Kiakshuk prints in the Nash collection, such as *The Legend of Lumiuk* and *Two Men Killing Giant* (shown on opposite page) and *Sea Monsters Devouring Whale,* delve into the relationship between the Inuit and the spirit world.

Over the years, many Inuit artists have portrayed, in both prints and sculptures, the transformative powers of the shaman, or *angakok,* in bridging the divide between the earthly and spiritual worlds. Traditionally, the primary purpose behind a wide array of rites and prohibitions throughout the Canadian Arctic was to propitiate the inhabitants of the spirit world, especially those that controlled the food supply. The *angakok* was a highly respected leader who was able to unite the two worlds through his powers and superb knowledge of nature and the seasonal patterns of birds and mammals of sea and land. The direct link between humans and animals can often be seen in works such as Eegyvadluk Ragee's *Vision of Caribou* (see next page), in which elements of human and animal forms are intermingled, prompting the question, Whose vision is this—the hunter's, the caribou's, or both?

A contemporary of Kiakshuk's, another hunter who was introduced to drawing late in life and became a prolific artist, producing more than two thousand drawings, was Parr (1893–1969). The three works by Parr in the Nash collection (*Day's End* [pl. 4], *Man among Walrus, Man and Whale*) all exhibit an easily recognizable style that has been

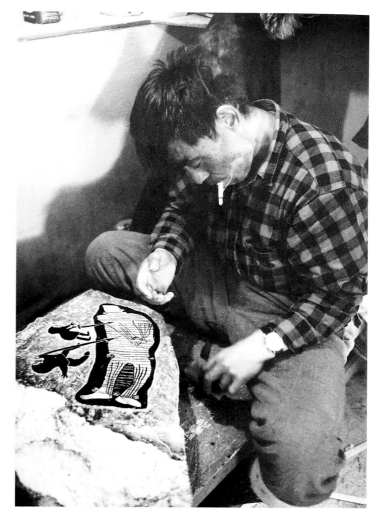

Iyola Kingwatsiak preparing the stone for the print *Two Men Killing Giant,* 1962. © Library and Archives Canada. Reproduced with the permission of Library and Archives Canada. Source: Library and Archives Canada/Credit: Charles Gimpel/Charles Gimpel fonds/PA-210894.

Eegyvadluk Ragee (1920–1983), *Vision of Caribou*. Stonecut printed by Lukta Qiatsuq, Kinngait (Cape Dorset), 1960. 32/50. 59.2 × 66.4 cm. PM 61-22-10/39039. 98810034.

described as almost childlike in its simplicity. Parr's work underwent significant transformation throughout his eight–year career as he moved from creating somewhat static figures to drawing images representing greater activity and more clearly defined spatial organization. Much of the recognition accorded to Parr and his work, including several solo exhibitions of his prints and drawings, has come since his death.[56]

In the late 1950s and early 1960s, increasing numbers of Inuit began moving from outlying camps to settlements established by the Canadian government in response to people's desire for medical services, education, and housing. There, they were confronted with a new and foreign lifestyle that was not always compatible with their native ways. By documenting their former nomadic lives as hunters, both Parr and Kiakshuk helped confirm an Inuit identity—for themselves as well as for viewers of their art—at a time of rapid and sometimes irreversible change.

Among the many talented women and men who tried their hands at drawing after observing others and realizing that making art could produce an income was Pitseolak Ashoona (1904–1983). Like other Inuit of her generation, Pitseolak spent her early years moving from one camp to another. After her husband's death, with several young children to care for, she moved into Kinngait. There, James Houston and Terry Ryan quickly recognized her talents, and her vibrant and energetic print images proved to hold immediate appeal for the public. Although Pitseolak believed that drawing took effort because it involved a lot of thinking, she could draw as many as six pictures in a single morning, and her drawings depicting traditional Inuit life and thought number more than seven thousand.[57] In recognition of her many outstanding artistic achieve–

ments over a two-and-a-half-decade career, she was elected to the Royal Canadian Academy of Arts in 1974 and awarded the Order of Canada in 1977.

According to her autobiography, Pitseolak especially liked the earliest drawings of those who, like Kiakshuk and Parr, depicted the old Inuit way of life. She said that in her first attempts to draw the old ways she tried to draw animals, but they came out looking like "little monsters." Because people approved and she was paid for her work, she continued to draw the old ways and "monsters" that she had heard about in stories.[58]

The two prints by Pitseolak in the Nash collection, *Perils of the Sea Traveller* (pl. 5) and *Figure with Serpent* (on next page), both reflect the use of black and brown, the two colors Pitseolak favored even after she began using brighter colors in her drawings. The one characteristic evident throughout much of her work is the representation of movement and activity, whether of people, animals, or mythical creatures.

Pitseolak's only daughter, Napachie Pootoogook (1938–2002), began to draw around the same time as her mother and had produced thousands of images by the time of her death. The Nash collection has four of her works: *Eskimo Sea Dreams* (pl. 6), *Eskimo Camp Scene*, *Sea Spirits*, and an untitled print. Although both mother and daughter depicted traditional themes in their drawings, the range of subject matter is much greater in Napachie's work, and she did not hesitate to illustrate the crueler aspects of traditional camp life, including arranged marriages and the abuse of women. Napachie, who was not only a notable artist but also an accomplished throat singer, devoted the last few years of her life to illustrating real and legendary stories that had been told to her by her mother and older brother. Some of these stories were about her paternal grandfather, who was a shaman, and the gradual conversion of the Inuit to Christianity.[59] She accompanied each drawing with a section of syllabic text by way of explanation. Napachie's legacy is carried on by her daughter Annie Pootoogook (b. 1969), who likewise portrays the realities of Inuit life in her drawings. Together with Napachie's niece, Suvinai Ashoona (b. 1961), and Kenojuak's adopted son, Arnaqu Ashevak (1956–2009), Annie Pootoogook represents the younger generation of notable graphic artists.

The work of one of Pitseolak's sons, Kiawak Ashoona (b. 1933), is represented in

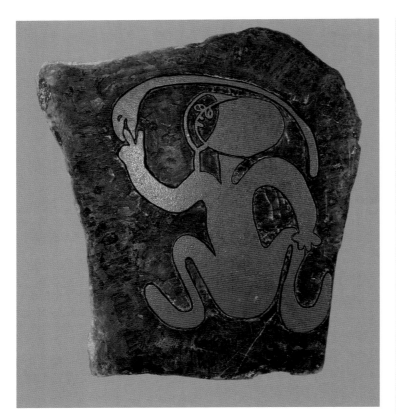

Stone block for *Figure with Serpent,* by Pitseolak Ashoona (1904–1983). Green stone with orange ink, 24.5 × 22 × 1.8 cm maximum (irregular). National Gallery of Canada, Ottawa (9733r). Gift of the West Baffin Eskimo Co-operative, Cape Dorset, Nunavut, 1961. Photo © NGC.

Pitseolak Ashoona (1904–1983), *Figure with Serpent.* Stonecut printed by Iyola Kingwatsiak, Kinngait (Cape Dorset), 1960. 18/50. 30.16 × 30.16 cm. PM 61-22-10/39053. 98810017.

the Nash collection by *Hawk and Fox*, the first of four of his images that were made into prints. Kiawak has been known primarily as an outstanding carver, and his sculptures, like those of his older brother, Qaqaq Ashoona (1928–1996), have been exhibited and collected worldwide. Kiawak started carving when he was only fourteen years old, and he was the first person in the Kinngait area to sell a carving to James Houston.[60] Pitseolak's family serves as but one example of the passing down of outstanding artistic talent from generation to generation.

Another early artist who helped build Kinngait's reputation as a cultural center was Kenojuak's aunt, Lucy Qinnuayuak (1915–1982), who was born in Nunavik but moved to the Kinngait area as a young child. A contemporary of Pitseolak's, Lucy was a prolific artist, creating thousands of images during a span of two decades. One hundred and thirty-six of her prints were published in twenty-one annual Kinngait print releases between 1961 and her death in 1982. Lucy drew what she knew best from her own experience, especially camp scenes, traditional women's roles, and a large array of birds, but her work was nevertheless infused with the myths and fantasies surrounding Inuit culture. Lucy was quoted in the 1978 Kinngait print catalogue as saying that although she found drawing difficult and did not, at first, want others to see her work, she was pleased to find out that people liked it.[61] Like Pitseolak, Lucy was grateful that drawing could provide her with an income to support her family, especially during her husband's extended illness.

Lucy Qinnuayuak's art has received wide recognition over the years. Her drawings and prints have been shown in countless group and solo exhibits, included in many collections, and chosen to decorate greeting cards, calendars, and a banner for the 1976 Summer Olympics, held in Montreal. The three prints by Lucy in the Peabody Museum's Nash collection, *Family Startled by Goose* (pl. 7), *Eskimo Woman with Fish Spear* (on p. 78), and *Owl and Companion* (on p. 112), all convey the sense of humor, whimsy, and playfulness so characteristic of much of Lucy's work.

Several residents of the Kinngait area, especially men, who tried their hands at drawing in the early years eventually discontinued it in favor of sculpting, stonecutting, or printing. Thus the drawings and prints of these artists add an important layer to the history of printmaking in Kinngait. Three whose images form part of the

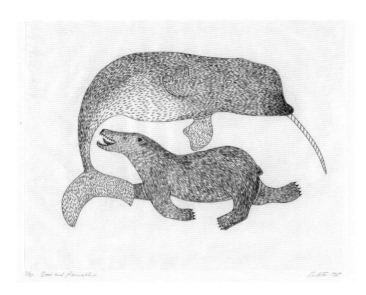

Lukta Qiatsuq (1928–2004), *Bear and Narwhal.* Engraving printed by Lukta Qiatsuq, Kinngait (Cape Dorset), 1964–1965. 7/50. 29.85 × 42.86 cm. PM 66-25-10/44162. 98810007.

Nash collection but who made their marks primarily as printers and stonecutters are Lukta Qiatsuq (1928–2004), Timothy Ottochie (1904–1982), and Qabavoak Qatsiya (b. 1942).

Lukta, the son of Kiakshuk, worked with James Houston on the earliest experiments in printmaking. By the time he left the print shop permanently in 1984, he had contributed to almost every print collection in most media. Lukta, who was also a stone block cutter and a master carver, printed approximately one-third of the prints in the Nash collection, including many of his father's works. The Nash collection includes the engraving *Bear and Narwhal*, one of a dozen or so drawings by Lukta that were made into prints between the late 1950s and the mid-1960s. With few exceptions, Lukta printed his own works.

Timothy Ottochie, another major contributor to the Kinngait print shop, produced seven of his own engravings, all part of the 1962 and 1963 print collections, before turning exclusively to cutting, inking, and printing the work of others (see illustration on p. 40). The Peabody Museum has one of these early Ottochie engravings, an untitled hunting scene. Terry Ryan speaks of Ottochie's outstanding talent as a stone block cutter. As time went on, Ottochie devoted more and more of his effort to this task, leaving the proofing process, which could be lengthy and tedious before the right combination of color and tone was achieved, to others.[62]

Qabavoak Qatsiya, another carver and also an accomplished throat singer, worked in the print shop from 1973 to 1984 before leaving because of his heavy involvement in other community activities. Two of his drawings had been translated into prints ten years or more before his employment in the print shop. The Nash collection includes one of those prints, a stencil titled *Two Birds, One Duck* (see illustration on p. 30). Most of the men who worked in the print shop were hunters, and they usually drew the

subject matter for their art, whether carving or drawing, from what they knew best—hunting and objects of the hunt.

It seems fitting to close this brief overview of early Kinngait graphic art and selected artists with Pudlo Pudlat (1916–1992) and his wife, Inukjuakjuk (1913–1972). Both embodied an indomitable spirit that helped them to pursue their artistic endeavors through even the most trying of times. Pudlo's nearly two hundred catalogued prints barely begin to touch upon his output of thousands of drawings over a span of thirty-three years. Pudlo started his career carving, but after a hunting accident and a long hospitalization, it became evident that drawing was his real passion, and eventually he stopped carving completely.[63] The Nash collection has one of Pudlo's earliest prints, *Caribou Chased by Wolf* (pl. 8), a stencil from the period when Kinngait artists were still drawing with graphite pencils and Pudlo had not yet begun to experiment with spatial relationships, unusual combinations of the traditional and the contemporary, and other creative forms of expression that became his trademarks. In 1990 Pudlo was honored with a solo show of his works at the National Gallery of Canada, the first such show at the gallery for an Inuit artist.

Inukjuakjuk, who may have started to draw somewhat earlier than her husband, had a much shorter career than he, because of her failing health. Nonetheless, the two worked together closely for about ten years, and more than a dozen of Inukjuakjuk's drawings were translated into prints, five of them appearing as early as the 1960 Kinngait print catalogue.[64] The four prints by Inukjuakjuk in the Nash collection, *Hunters and Rabbits* (pl. 9), *Eskimo Mother and Children* (on p. 84), *Autumn Migration,* and *Female Owl* (see frontispiece), record elements of her daily life: hunters, birds, and motherhood. One can only wonder in what direction Inukjuakjuk's talents and close collaboration with her husband might have taken her had she lived longer.

The scope of this book precludes a discussion of all the graphic artists represented in the Nash collection, but many residents of the Kinngait area became involved in the graphic arts program early on. For some, art became a way of life and a vital means of providing for their families. The work of others, such as Achealak Qatjuayuk (1911–1995), is known through only a single editioned print. Still others, such as Sheouak

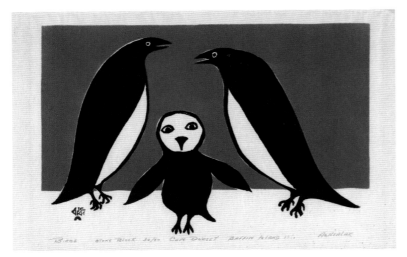

Achealak Qatjuayuk (1911–1995), *Birds*. Stonecut printed by Lukta Qiatsuq, Kinngait (Cape Dorset), 1960. 32/50. 30.5 × 48 cm. PM 61-22-10/39037. 98810009.

Petaulassie (1918–1961), whose career was cut short after only three years by her untimely death, left behind bodies of work that have received considerable attention over the years. One of Sheouak's designs is the symbol still used to represent the West Baffin Eskimo Co-operative.

Every one of the sixty prints in the Nash collection deserves attention, not only for its intrinsic qualities but also for what it tells us about its creator and its place in the early history of Inuit printmaking. Kinngait paved the way for other Inuit communities, and in time, renowned artists such as Jessie Oonark (1906–1985) of Qamanittuaq (Baker Lake), whose earliest drawings were translated into prints at Kinngait (pl. 10), had their own print shops. In the 1983 Kinngait graphics annual, Terry Ryan referred to the first twenty-five years as the Dorset graphic arts experiment and reflected on its future.[65] Today, at the fifty-year mark, it seems safe to say that the "experiment" has been a resounding success.

NASH COLLECTION SCULPTURES

All the prints in the Nash collection were part of annual catalogued releases, so ample documentation exists concerning them and the artists who produced them. The same, unfortunately, cannot be said for the 210 sculptures in the collection. Only one-fifth of the carvings have been attributed to specific artists, and even that information is often sketchy and unreliable. Although the majority of the sculptures have been associated with a particular community, the most detail we have about a few is that they originated somewhere in the Hudson Bay region.

There are many reasons for the anonymity of artists who produced sculptures in the early years of contemporary Inuit art. One is the prevailing notion of the time that in

order for "primitive" art to be authentic, it had to be anonymous.[66] Early sculptures were often unsigned, either in Inuktitut syllabics, in Roman orthography, or by disc number, and were unaccompanied by an "igloo tag"—a string tag or sticker bearing the symbol of an igloo, which the Canadian government developed to distinguish original Inuit art from imitations and to counter the proliferation of fakes. Another reason for the anonymity is that non–Inuktitut speakers often misunderstood and improperly recorded information given to them verbally. In recent years, researchers have tried to rectify this situation and identify as many of the artists as possible, a laborious and sometimes futile effort. In one recent project, Darlene Wight, curator of Inuit art at the Winnipeg Art Gallery, designed a database of images and other information to use as the basis for interviews with residents of three Inuit communities and for comparisons with other works. She has successfully attributed artists to fifty-five previously unidentified pieces in the gallery's collection.[67]

Approximately 20 percent of the sculptures in the Nash collection came from communities in Nunavik. The rest originated in communities of Nunavut, with those by artists from Naujaat (Repulse Bay), Qausuittuq (Resolute), and Kugaaruk (Pelly Bay) predominating. Kangiqliniq (Rankin Inlet) and Qamanittuaq (Baker Lake) are also well represented. Whereas most of the graphic art in the collection is the work of Kinngait artists, only a handful of the carvings came from the Baffin Island region, including Kinngait and Kimmirut (Lake Harbour). In addition to contemporary Inuit sculpture, Chauncey Nash donated about a dozen stone, bone, and ivory objects such as knife blades and harpoon heads to the Peabody Museum. Most of these are thought to be of Thule origin, and a few perhaps late Dorset (pl. 13).

Slightly more than half the sculptures in the Nash collection were carved from stone. The rest were fashioned from ivory, whalebone, antler, or a combination of materials. Because stone has long been a favorite carving medium of many contem-

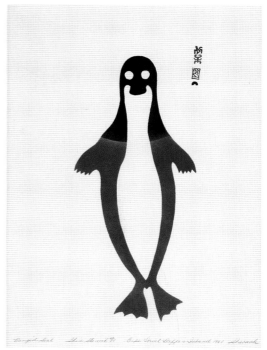

Sheouak Petaulassie (1918–1961), *Ringed Seal.* Stencil printed by Eegyvudluk Pootoogook, Kinngait (Cape Dorset), 1960. 42/50. 53.7 × 31 cm. PM 61-22-10/39056. 98810026.

porary Inuit artists, many sources of carving stone have been almost depleted. Even when stone is available, obtaining it may require lengthy travel to a quarry and work under dangerous conditions to get it out of the ground. Thus, in addition to stone, Inuit artists have always used other, more readily available resources, including caribou antler, walrus ivory, and whalebone, especially when stone has been in short supply. Panniqtuuq artists, for example, have become well known for their use of whalebone, which has been easily available to them because of the commercial whaling that took place in the Cumberland Sound area in the nineteenth and early twentieth centuries. Current worldwide regulations concerning the importation and trade of marine mammal products, however, limit the potential for artists to market carvings from bone and ivory. Today's Inuit artists, especially those who live and work in southern Canada, often use stone such as Italian alabaster, Brazilian soapstone, and marble that they have purchased from any number of sources.[68]

Whereas printmaking is associated with only a handful of northern Inuit communities, carving is an important source of income for Inuit in most Arctic communities. The importance of carving stone to the economy of Canada's North can be seen in the 1993 Nunavut Land Claims Agreement, which accorded to every Inuk the right to remove fifty cubic yards of carving stone a year, including serpentinite, argillite, and soapstone, without a permit. The agreement includes the right to remove stone from land subject to other interests as long as there is no significant damage to or interference with the interest holder's use of the land.[69] One often hears the word *soapstone* used generically to refer to Inuit stone carving, but in fact true soapstone, which is composed primarily of talc, an extremely soft mineral, is poorly suited to carving, because it can be scratched and breaks easily. Stone more suitable for carving contains harder minerals as well, and even a soft stone such as steatite, which Nunavik artists often use, contains minerals other than talc.

Many factors come into play in distinguishing the sculpture of one community from that of another, carving material being but one of them. Especially in the 1950s and 1960s, when the sculptures in the Nash collection were made, regional and local styles abounded. Just as in graphic arts, however, individual styles play a role equal to, if not more important than, place of origin in distinguishing one piece from another,

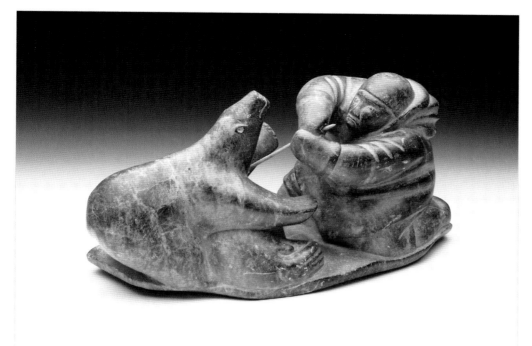

and they show that Inuit sculpture has never been a homogeneous art. Only because the makers of so many pieces in the Nash collection remain unidentified is it justifiable to discuss the works through reference to regions or communities.

In the earliest group of contemporary Inuit sculptures that Nash donated to the Peabody Museum, pieces from Nunavik, especially the community of Puvirnituq, predominate. Early Nunavik sculpture was among the first to be shown to the public at large, and it came to represent a conservative tradition that many observers still associate with Inuit art, despite the changes and innovations that have taken place over the years.[70] Sculpture from this region is often described as realistic and naturalistic, and the carvers gave special emphasis to details such as carefully incised hair and facial features (pl. 14). Their favorite subjects included animals,

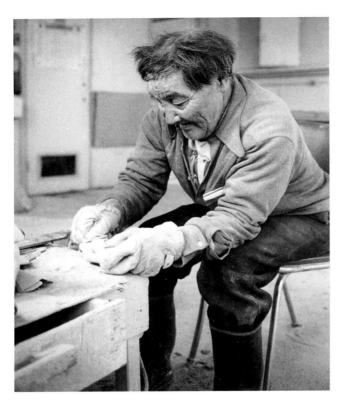

John Kavik, Kangiqliniq (Rankin Inlet), 1974. Photo © Canadian Museum of Civilization, David Zimmerly.

birds (pl. 24), fish, and action–filled hunting scenes (pls. 15, 16). They often carved in steatite, a soft gray stone, which they often blackened and then incised to show greater detail. In addition to Puvirnituq, other Nunavik communities represented in the collection are Kangiqsujuaq (Wakeham Bay), Inukjuak (Port Harrison), Kangirsuk (Payne Bay), Ivujivik (Wolstenholme), and Salluit (Sugluk).

Although Baffin Island is represented in the Nash collection by only a handful of pieces, they form an important component of this early group of sculptures. Quarries in the southern part of the island produced stone in an especially large variety of colors, densities, degrees of luster and hardness, and other desirable physical properties. This variety, combined with the high quality of the stone, had a direct effect on the sculptures produced in that area and fostered experimentation and creativity. Kinngait sculpture, especially, went beyond the straightforward depiction of animal and human forms to more complex compositions embodying ideas from the spiritual and supernatural realms.[71] Especially striking in pieces from Kinngait and Kimmirut are the high sheen obtained from working a relatively hard stone such as serpentine or serpentinite, which is common in that area, and colors that can range from bright green (illustrations on p. 98 and pl. 17) to more muted, variegated colors (pl. 18).

Sculpture from the western coast of Hudson Bay and Qamanittuaq (Baker Lake), the only inland community of the Canadian Arctic, exhibits considerable differences from that of other, perhaps traditionally less isolated places. The hard, gray to black stone obtainable in the area does not lend itself to fine detail, and some of the pieces in the Nash collection have a rough and rugged, almost unfinished feel to them. Ingo Hessel, an independent curator, writer, and consultant on Inuit art, described the

works of John Kavik (1897–1993; pl. 19), one of the best-known artists from Kangiqliniq (Rankin Inlet), as evoking a visceral emotion in the viewer even without communicating exactly what the artist is trying to say.[72] The sculpture of this area strongly emphasizes human forms—individually, in pairs and groups, or simply as faces (pls. 19, 20). The Nash collection has about two dozen works from the communities of Qamanittuaq, Kangiqliniq, and Igluligaarjuk (Chesterfield Inlet).

Close to a hundred sculptures in the Nash collection came from the northwest Hudson Bay coastal communities of Kugaaruk (Pelly Bay) and Naujaat (Repulse Bay). Since the late nineteenth century this area has been known for its miniature carvings in ivory, stone, antler, or a combination of materials (pls. 21, 22), which Roman Catholic missionaries encouraged Inuit to produce for trade with whalers and explorers. The subject matter consists largely of human and animal forms and activities connected with hunting. Half the pieces from this area found in the Nash collection are ivory miniatures, and the rest are miniatures or larger carvings made from stone, bone, antler, or combinations thereof (pls. 23, 24). One piece in the collection is by the well-known artist Mark Tungilik (1913–1986; pl. 25), who was born in Kugaaruk but moved to Naujaat. Although people in Kugaaruk continued to carve miniatures into the contemporary period, large sculptures fashioned of material such as whalebone, making direct reference to the traditional belief system, became the norm (see illustration on this page). Such was not the case in Naujaat, where subjects of hunting and camp life continued to dominate.

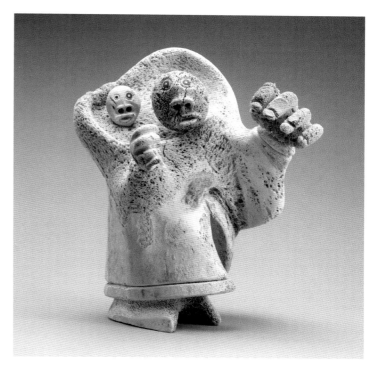

Karoo Ashevak (1940–1974), *The Coming and Going of the Shaman,* c. 1973. Karoo Ashevak, who was from Taloyoak (Spence Bay)—one of the last Inuit communities, together with Kugaaruk, to be affected by Western civilization—became especially well known for his whalebone carvings depicting the spirit world. Using the familiar form of a mother and child, in this work he portrays a female shaman transferring her powers to a younger apprentice. Whalebone, antler, and stone. 38.5 × 27 × 29.5 cm. National Gallery of Canada, Ottawa (35877.1-5). © Public Trustee for Nunavut, estate of Karoo Ashevak. Photo © NGC.

Almost three dozen sculptures in the Nash collection came from Qausuittuq (Resolute) and Aujuittuq (Grise Fiord), the two northernmost communities of the Canadian Arctic. It is difficult to categorize these works, because the Inuit families in the two communities were not native to the area but had been relocated there by the federal government from the Nunavik community of Inukjuak and the Nunavut community of Mittimatalik (Pond Inlet) between 1953 and 1955.[73] Cooperative societies, which were involved in the buying and selling of carvings and crafts, had been established in both communities by the end of 1960. In Chauncey Nash's correspondence, Brother Volant referred frequently to direct contact with people in Qausuittuq as a means of obtaining carvings.

Observing the sculptures in the Nash collection in their entirety, one cannot help noticing a dearth of "transformative" pieces, which depict the supernatural world and the real world as becoming one, and of representations of shamans, spirits, and mythological beings. With few exceptions, these sculptures portray activities of everyday life: camp and hunting scenes and the humans and wildlife that are part of these activities. One can speculate that Nash purchased what was available to him at the time or that Inuit artists were creating what they thought the public wanted to see. Judging from the correspondence between Nash and Volant, however, these were the kinds of carvings Nash wanted and requested—pieces that tied in closely with his interests in nature, wildlife, and the outdoors. It is this feature of simplicity and transparency that distinguishes the Chauncey C. Nash sculpture collection from many others. These early pieces seem to speak directly to the "truth" and "reality" that Inuit artists see as integral ingredients in all their work.

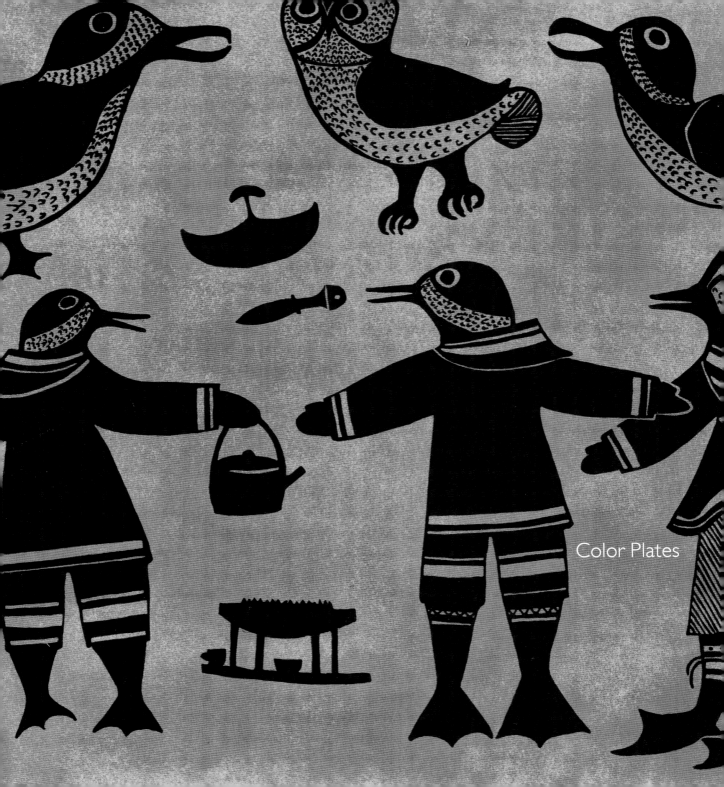

PLATE 1

The Return of the Sun
ARTIST: Kenojuak Ashevak,
b. 1927
Stonecut, 14/50*
Printer: Lukta Qiatsuq
Kinngait (Cape Dorset), 1961
61.8 × 85.8 cm
PM 62-3-10/40705

IN THIS PRINT, which was reproduced on a Canadian seventeen-cent stamp in 1980, one can see both the influence of Kenojuak's earlier work sewing sealskin clothing and other objects and her later technique of starting with one idea, such as a single bird, and elaborating on it with extensions, additions, and decorations. The elements in this print are not unlike the cutouts she might have used for decorating a parka. Her first print, *Rabbit Eating Seaweed*, was not based on a drawing but rather was a design traced from a sealskin handbag she had made earlier.

The formal structure of this print is similar to that of several others by Kenojuak from the early 1960s, whereby individual fluid forms fuse into one another, giving the impression of a continuum without beginning or end. As Jean Blodgett observed, "her pencil seemed never to leave the paper."[74]

Subjects in Kenojuak's earliest prints were diverse, ranging from birds with fantastic plumage and transformed creatures such as the bird–humans seen on the cover of this book to the straightforward depiction of a hunter spearing a seal in an untitled print from 1962. *The Return of the Sun* can be viewed from several perspectives. The first rays of sun after a dark Arctic winter signal an important change in the daily round of life for humans and animals alike, and tales about the sun and the moon form important parts of Inuit mythology. Yet as Kenojuak herself said during an interview with Jean Blodgett in May 1980, her overriding concern was with aesthetics, not representation: "I just take these things out of my thoughts, and out of my imagination, and I don't really give any weight to the idea of its being an image of something. In other words, I am not trying to show what anything looks like in the material world. I am just concentrating on placing it down on paper in a way that is pleasing to my own eye, whether it has anything to do with subjective reality or not."[75] (Opposite: 98810025.)

Kenojuak Ashevak, Kinngait (Cape Dorset), 1960. Source: Library and Archives Canada/Credit: Rosemary Gilliat/National Film Board of Canada. Photothèque collection/PA-146503.

* 14/50 = Print number 14 from an edition of 50.

The Return of the Sun Stone Cut #41/50 Cape Dorset N.W.T. 1961 Kenojuak

PLATE 2
Summer Caribou
ARTIST: Kananginak Pootoogook,
1935–2010
Engraving, 9/50
Printer: Kananginak Pootoogook
Kinngait (Cape Dorset),
1964–1965
31.5 × 45.6 cm
PM 967-72-10/45941

ALTHOUGH MOST OF KANANGINAK'S DRAWINGS that were made into prints in the 1960s were of birds, his special interest since early childhood, he said that his first drawing was of a caribou.[76] His keen eye for the physical traits and movements of all forms of Arctic wildlife manifested itself in the fine detail and realism that characterize his work. Kananginak's respect for wildlife became evident whenever he spoke about his life or art: "The older people wisely told us that killing animals must be purposeful, and not simply for sport. Long ago the old people used to tell us that animals were made by a great spirit in order for the Inuit to have food. I learned that a wise hunter should not boast about his success at the hunt, or he would have difficulty in future hunts."[77]

The medium of engraving, and later that of lithography, was especially suitable for Kananginak's drawings, in that he himself could work directly on the plate, applying as many fine incisions as needed to attain the desired shading and other effects. All but three of Kananginak's twenty-four editioned prints from the 1960s are engravings.

The lifelike stance, proportions, and shading of the caribou in this print bear close resemblance to what one might see in a photograph of the animal. This realism contrasts sharply with the style of many other Inuit artists of the same period, for whom realism was not necessarily a primary concern. Other printers who worked with Kananginak's images seemed to appreciate the realistic quality of his work, because it made decisions about aspects of the printing process such as color and texture easier.

Before the introduction of engraving in Kinngait, an artist had little involvement with his or her own work once it entered the studio to be translated into a stonecut or a stencil. Engraving offered an additional choice of medium, and often the artist was also the printer of the work, as was the case with *Summer Caribou*. (Opposite: 98810030.)

9/50 Summer Caribou Kananginak 1964

PLATE 3
Summer Camp Scene
ARTIST: Kiakshuk, 1886–1966
Stencil, 11/50
Printer: Lukta Qiatsuq
Kinngait (Cape Dorset), 1961
60 × 71.5 cm
PM 62-3-10/40692

WHEREAS MANY OF KIAKSHUK'S IMAGES remind us of the dangers and uncontrollable forces at work in the Inuit world, this print conveys a busy yet almost idyllic summer day. Success in hunting is evident in the polar bear skins drying on a line, sealskin floats hanging from tents, and sealskins being stretched out on the ground to dry by the women. In this narrative one can almost picture children playing nearby while the adults perform their prescribed roles—tasks related to hunting for men and skin preparation for women.

The 1964–1965 Cape Dorset print catalogue says that Kiakshuk remembered the days of hunting caribou on foot, crawling up to a seal with only a harpoon, catching geese in stone traps, and doing the drum dance.[78] But although Kiakshuk had lived most of his life following traditional ways, he was fully grounded in the present and understood the changing world around him. His 1961 drawing *Music and Dancing*, held by the National Gallery of Canada, acknowledges musical genres introduced in the Arctic by Scottish and American whalers in the nineteenth century. In that drawing, an accordion player and a fiddle player provide music for a dance. Kiakshuk, known for using precise details to record his recollections and observations, differentiated between the young dancers and the older observers by giving the dancers Western clothing.

Summer Camp Scene is one of a dozen or more of Kiakshuk's images that were translated into prints by his son, Lukta Qiatsuq (see illustration on p. 12). Lukta became highly proficient in all aspects of print production in almost all media, including stonecutting, stenciling, engraving, and combinations of techniques. (Opposite: 98810029.)

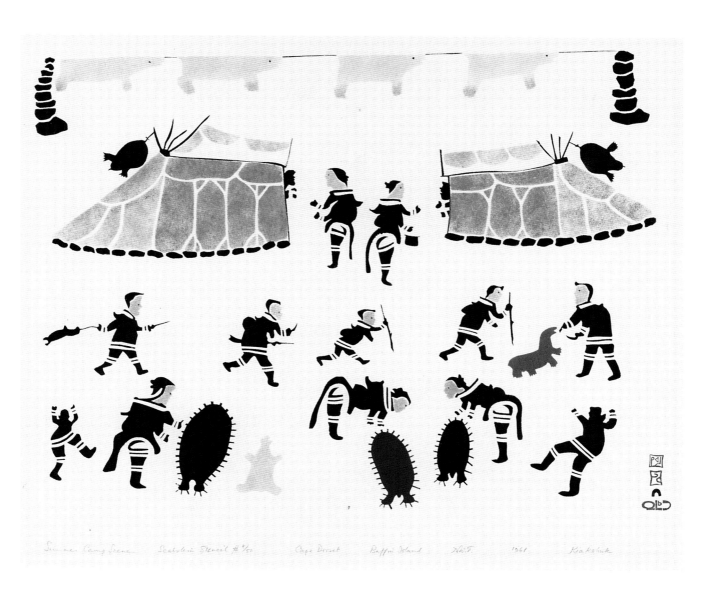

Summer Camp Scene Sealskin Stencil #8/50 Cape Dorset Baffin Island N.W.T. 1961 Kiakshuk

PLATE 4

Day's End
ARTIST: Parr, 1893–1969
Stonecut, 12/50
Printer: Iyola Kingwatsiak
Kinngait (Cape Dorset), 1962
40.3 × 63.1 cm
PM 64-34-10/43978

PARR'S IMAGES HAVE AN ABSTRACT QUALITY, which immediately distinguishes his work from that of his contemporaries. This print is one of his earliest, made at a time when he was still drawing with graphite pencils. Eventually he experimented with wax crayons, felt pens, and pastels. Although Parr tried his hand at etching and engraving, drawing on paper was his preference, as is evidenced by his immense output of drawings.

The hunting life dominates Parr's work, which often depicts hunters in pursuit of game. Many of Parr's hunting scenes consist of human and animal figures with no additional points of reference such as landscape features. *Day's End* stands out for its delineation of a dwelling, with hunters resting indoors and their dogs sleeping outdoors after a hard day.

Iyola Kingwatsiak, the printer of this work, was one of the first Inuit to experiment with printmaking techniques, together with Kananginak Pootoogook and Lukta Qiatsuq and joined somewhat later by Kananginak's brother Eegyvudluk Pootoogook. Iyola, Lukta, and Eegyvudluk printed the majority of the works in the Nash collection (see illustration on p. 12). (Opposite: 98810011.)

PLATE 5
Perils of the Sea Traveller
ARTIST: Pitseolak Ashoona,
1904–1983
Stonecut, 18/50
Printer: Eegyvudluk Pootoogook
Kinngait (Cape Dorset), 1960
58.5 × 70 cm
PM 61-22-10/39054

Once I begin to draw, it always comes from my head, imagining, even if I have never seen it before. That's how I am. When I first start a drawing, I have a picture already made up in my mind, but as I go along, more ideas come and I just keep adding until finally the picture comes out by itself. —Pitseolak Ashoona, in *Dorset 78* (Cape Dorset print catalogue, 1978)

DURING EXTENSIVE INTERVIEWS with Dorothy Eber for the autobiographical book *Pitseolak: Pictures Out of My Life*, Pitseolak reminisced about life in the camps and wove descriptions of the old ways of doing things into discussions of her drawings. She recalled traveling with her family in a large sealskin boat called a women's boat, or *umiaq*. Such vessels, which were sewn by women, were already disappearing during her childhood, and so she put them into drawings like *Perils of the Sea Traveller*, illustrating the dangers of travel in rough seas.

In her book Pitseolak said, "In the old days, usually the women would row the sealskin boat and the men would go in the kayaks. In one drawing [*Perils of the Sea Traveller*], I have shown the women's boat towing a kayak. If it became rough they would take the kayak-man aboard. In this print, all around the boats are little pests. What are they doing there? It is their business to be there. Did Eskimos believe in spirits and pests and monsters? Maybe they did. In the old days there was much to fear." [79]

Pitseolak's son-in-law, Eegyvudluk Pootoogook, printed this work. Like the other pioneers of Inuit printmaking, Eegyvudluk was an outstanding carver as well. (Opposite: 98810024.)

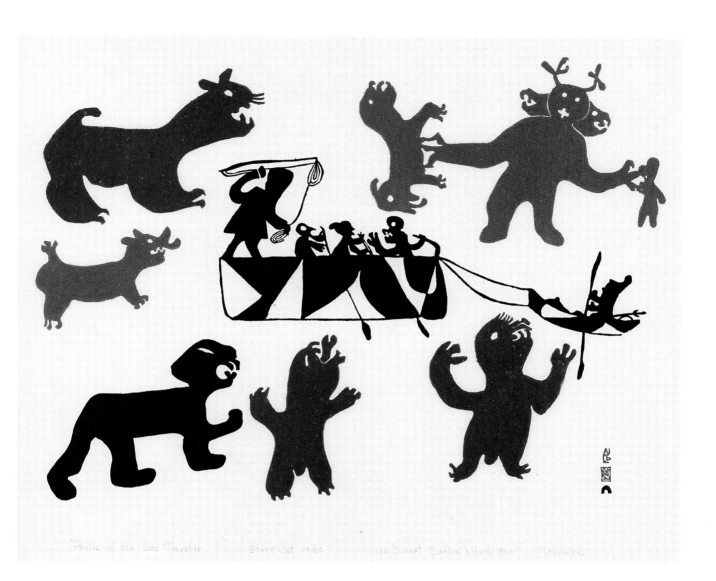

Perils of the Sea Traveller Stone Cut 10/50 Iyola Direct Baffin Island 1961 Cape Dorset

PLATE 6

Eskimo Sea Dreams
Napachie Pootoogook,
1938–2002
Stonecut, 33/50
Printer: Iyola Kingwatsiak
Kinngait (Cape Dorset), 1960
57.2 × 67.9 cm
PM 61-22-10/39052

SPEAKING ABOUT THIS PRINT during an interview in 1991, Napachie said, "The image is the whaling scene and telling a tale. Whales and bears and other animals turn into humans in Inuit mythology. It is depicting an Inuit myth even though I have not witnessed anything happening like that in real life."[80]

The transformation of humans into animals, animals into humans, and animals into other animals is a common theme in Inuit mythology. Inuit artists have used this idea readily, either to portray specific tales or, through the use of hybrid human–animal forms (as in Kenojuak's bird–humans on the cover of this book), to portray the close relationships among all living beings and their dependence on one another.

By the time of Napachie's death in 2002, her artistic output had, in a way, come full circle. In her early work she often drew what she had heard about but not necessarily experienced herself. Later she turned more to vignettes from her own life, as exemplified in her well-known 1989 lithograph *My New Accordion*. In her later years she turned once again to the past, focusing on stories told to her by her mother and older brother. (Opposite: 98810013.)

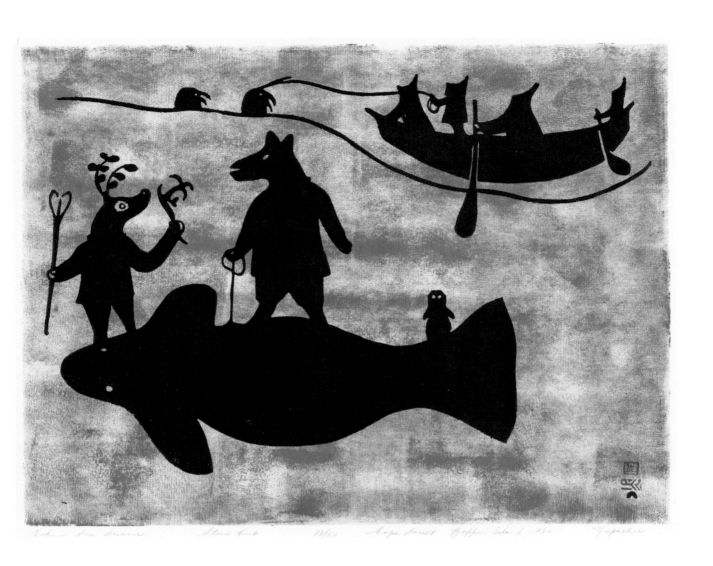

Eskimo Sea Dream Stone Cut 33/50 Cape Dorset Baffin Island 1960 Niviaksiak

PLATE 7
Family Startled by Goose
ARTIST: Lucy Qinnuayuak,
1915–1982
Stonecut, 27/50
Printer: Lukta Qiatsuq
Kinngait (Cape Dorset), 1961
47.5 × 60.8 cm
PM 62-3-10/40698

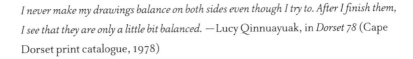

I never make my drawings balance on both sides even though I try to. After I finish them, I see that they are only a little bit balanced. —Lucy Qinnuayuak, in *Dorset 78* (Cape Dorset print catalogue, 1978)

IT WAS PRECISELY THROUGH a certain lack of balance and accuracy that Lucy achieved the humorous effects so prized by viewers of her art. By exaggerating some elements in her compositions and thereby distorting their relationships to others, she added to the atmosphere she was trying to convey. In *Family Startled by Goose,* the trio's anxiety is conveyed by the father's swift movement toward the child and by the positioning of the child, which gives the impression that she is flying through the air rather than running or walking. In remembering Lucy, her niece, Kenojuak Ashevak, said that her aunt especially enjoyed drawing geese.[81] This print is the earliest published example of that partiality. Lucy's ambivalence toward proportion and scale is particularly pronounced in *Eskimo Woman with Fish Spear,* shown on this page, in the relationship of the mother's head to both her own body and the head of the child in the hood of her woman's parka, or *amauti.* (Opposite: 98810015; left: 98810014.)

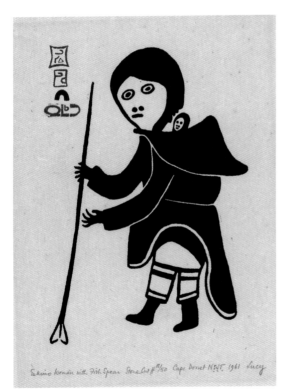

Lucy Qinnuayuak (1915–1982), *Eskimo Woman with Fish Spear.* Stonecut printed by Lukta Qiatsuq, Kinngait (Cape Dorset), 1961. 18/50. 30.8 × 20.9 cm. PM 62-3-10/40694. 98810014.

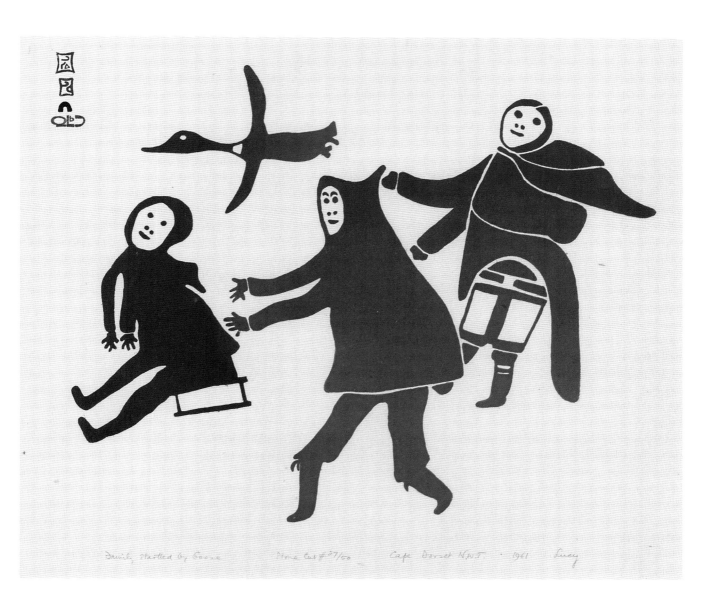

Family startled by Goose Stone Cut #27/50 Cape Dorset N.W.T. · 1961 Lucy

PLATE 8
Caribou Chased by Wolf
ARTIST: Pudlo Pudlat, 1916–1992
Stencil, 7/50
Printer: Eegyvudluk Pootoogook
Kinngait (Cape Dorset), 1961
55.2 × 70.2 cm
PM 62-3-10/40699

DURING A 1979 INTERVIEW Pudlo expressed his approach to art and life, as well as the curiosity and wonder that propelled him toward continual experimentation and growth: "If an artist draws a subject over and over again in different ways, then he will learn something. The same with someone who looks at drawings—if that person keeps looking at many drawings, then he will learn something from them too."[82] Pudlo was not afraid to incorporate nontraditional subjects such as airplanes in his work or to look at familiar objects with new eyes. Eventually he gravitated toward unique combinations of the old and new, such as airplanes with wings like a bird's, showing the commonality between the two forms of flight.

Caribou Chased by Wolf represents Pudlo's earliest period of drawing, when he focused mainly on animal, bird, and human forms, all carefully outlined, strategically placed, and drawn in perfect proportion to one another. (Opposite: 98810010.)

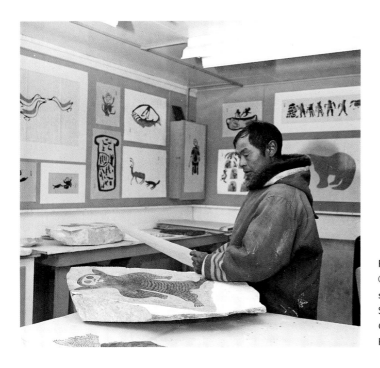

Pudlo Pudlat in the Kinngait printing studio, 1961. © Government of Canada. Reproduced with the permission of the Minister of Public Works and Government Services Canada (2010). Source: Library and Archives Canada/Credit: B. Korda/National Film Board of Canada. Photothèque collection/PA-145608.

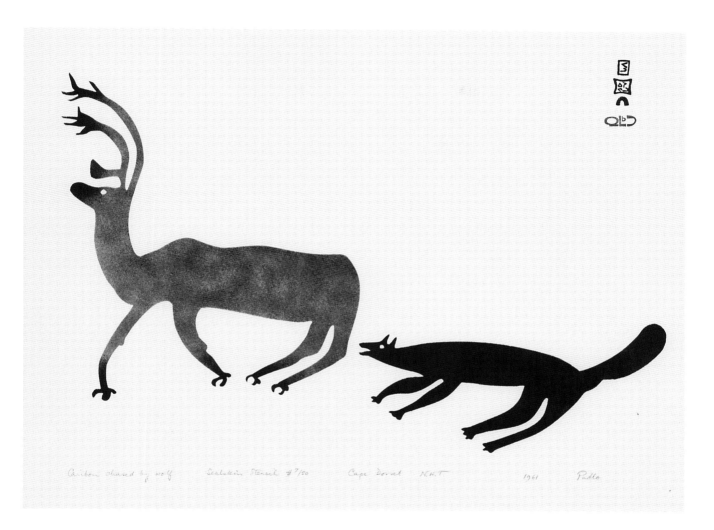

Caribou chased by wolf Sealskin Stencil #7/50 Cape Dorset N.W.T. 1961 Pudlo

PLATE 9

Hunters and Rabbits
ARTIST: Inukjuakjuk Pudlat,
1913–1972
Stonecut, 11/50
Printer: Iyola Kingwatsiak
Kinngait (Cape Dorset),
1964–1965
43.2 × 60.8 cm
PM 66-25-10/44167

THIS WAS ONE OF FIVE IMAGES by Inukjuakjuk that appeared in the combined 1964–1965 Cape Dorset print catalogue. Although scholars have pointed out similarities between Inukjuakjuk's work and early images by her husband, Pudlo, a unique woman's perspective certainly emerges in some of her art. The clothing of the hunters in *Hunters and Rabbits*, like the detailed female clothing depicted in *Eskimo Mother and Children* (see illustration on p. 84), affirms the Inuit woman's role in preparing skins and sewing garments and denotes unambiguously that the viewer is looking at a representation of something Inuit.

Even though *Hunters and Rabbits* includes no overt delineation of landscape, an implication of depth in the image makes it easy to visualize the rabbits as being on land, closer to the viewer, and the hunters farther away, harpooning the seal on sea ice. Similarly, in her 1960 print *Autumn Migration*, Inukjuakjuk implied a relationship between land and sky through the size, form, and placement of a group of geese. While Pudlo moved quickly to incorporate new subjects in his drawings, Inukjuakjuk presented the realities of her own life in new and creative ways. (Opposite: 98810018.)

11/50 Hunters and Rabbits Stone Cut Inukjuakju 1964

PLATE 10

Inland Eskimo Woman
ARTIST: Jessie Oonark, 1906–1985
Stonecut, 18/50
Printer: Eegyvudluk Pootoogook
Kinngait (Cape Dorset), 1960
55.3 × 32 cm
PM 61-22-10/39057

SEVERAL YEARS BEFORE the Nunavut community of Qamanittuaq (Baker Lake) had its own graphic arts program, six drawings by Jessie Oonark were sent to the print shop in Kinngait for possible printing. Two of these, including *Inland Eskimo Woman*, appeared in the 1960 Kinngait print release. *People of the Inland*, the other Oonark print in the Nash collection, was released at Kinngait in 1961.

Jessie Oonark, or Una, a prolific artist who played a major role in the development of the Qamanittuaq graphic arts program, also made her mark as an outstanding textile artist. No doubt both her prints and her appliquéd wall hangings were heavily influenced by her acute sense of form and design, which was already evident in the garments she produced for sale before starting her career as an artist.[83] Oonark is one of only four Inuit artists who have been honored with membership in both the Royal Canadian Academy of Arts and the Order of Canada.

Traditional dress is a common theme in Inuit art and legend. Although hand-sewn clothing no longer holds center stage in Inuit life, as it once did, it remains a strong symbol of the cooperation and reciprocity between men and women that was essential for survival in a harsh environment.[84] The depictions of the female parka, or *amauti*, on these two pages stand in stark contrast to each other. Oonark's abstract rendition plays on the viewer's imagination, whereas the parka in Inukjuakjuk's *Eskimo Mother and Children* is represented realistically, with inlays of soft, white skin from the underbelly of the caribou. (Opposite: 98810020; left: 98810012.)

Inukjuakjuk Pudlat (1913–1972), *Eskimo Mother and Children*. Stonecut printed by Iyola Kingwatsiak, Kinngait (Cape Dorset), 1960. 18/50. 43 × 32 cm. PM 61-22-10/39041. 98810012.

Iʃland Eskimo Woman Edition Print 35/50 Cape Dorset 1960 Ebela (Kiagna Kaʃa)

PLATE 11
Sea Goddess Feeding Young
ARTIST: Saggiassie Ragee,
1924–2003
Stonecut, 44/50
Printer: Eegyvudluk Pootoogook
Kinngait (Cape Dorset), 1961
41.3 × 49.8 cm
PM 62-3-10/40687

THE SEA GODDESS HAS BEEN a frequent and popular subject in Inuit art. Called by various names, including Sedna, Taleelayuk, and Nuliayuk, she is the central figure in Inuit mythology throughout the coastal communities of the Canadian Arctic. Many versions of her story exist. According to one version told to the ethnographer Franz Boas, Sedna, a beautiful girl who refused all offers of marriage, was tricked into marrying a fulmar, an Arctic seabird. When her father at last rescued her, after killing the fulmar, and set out to take her home in his boat, the other fulmars angrily caused a violent storm to commence. Sedna's father, fearing for his life, threw Sedna overboard. As she clung to the side of the boat, he cut off her fingers, which became seals and whales. Sedna henceforth became the guardian of sea mammals. She was considered the spirit most responsible for the well-being of the Inuit but also the spirit to be feared the most.[85]

This depiction by Saggiassie Ragee, a hunter and carver who was married to the graphic artist Eegyvadluk Ragee (1920–1983; see illustration on p. 46), portrays Sedna as a nurturing and benevolent being rather than a spirit to be dreaded. (Opposite: 98810027.)

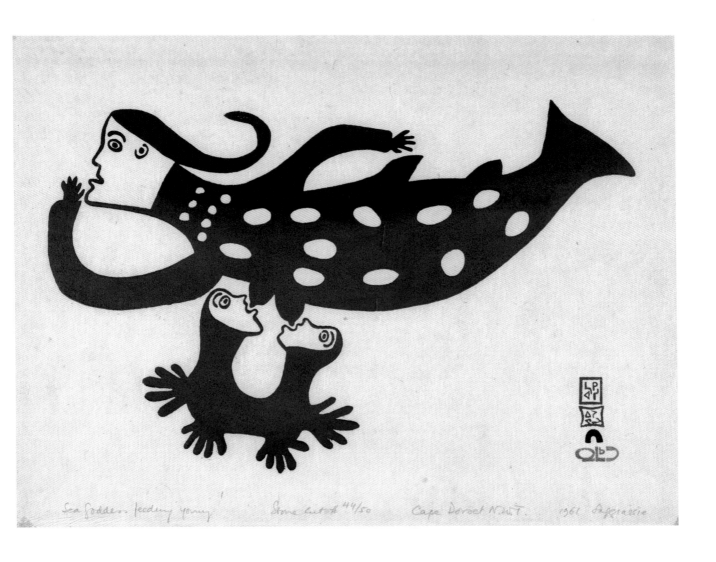

Sea Goddess feeding young Stone cut #44/50 Cape Dorset N.W.T. 1961 Agpasssie

PLATE 12

Seal Hunter Reaching Home
ARTIST: Annie Mikpigak,
1900–1984
Stonecut, 18/20
Printer: Annie Mikpigak
Puvirnituq (Povungnituk), 1962
40.3 × 58.8 cm
PM 64-34-10/43980

THIS PRINT IS ONE OF THREE in the Peabody Museum collection from the Puvirnituq (Povungnituk) print shop. Stonecut printing was introduced in Puvirnituq in 1961, with the establishment of the Povungnituk Co-operative Association, and the earliest prints from its studio appeared as part of the 1962 Kinngait print catalogue. Several other Nunavik communities became involved in printmaking as well, but their print shops eventually closed, as did the one in Puvirnituq in 1989.

The printing process used in Puvirnituq differed from that of Kinngait. Most Puvirnituq artists cut their own images directly into stone and sold the entire stone block to the co-op, rather than just the drawing. The style of the prints also differed from the Kinngait style, in that Puvirnituq artists preferred to frame an image with rough edges or the irregular contour of the stone itself, thus giving the stonecut a uniquely rugged quality.[86]

Annie Mikpigak, who probably carved all her own stones, produced more than fifty images in eight Puvirnituq collections between 1962 and 1973. *Seal Hunter Reaching Home* is a good example of the typically dark tones of Puvirnituq prints as well as the traditional subject of hunting. As in so many other Puvirnituq prints, the artist incised her signature directly into the stone. (Opposite: 98810028.)

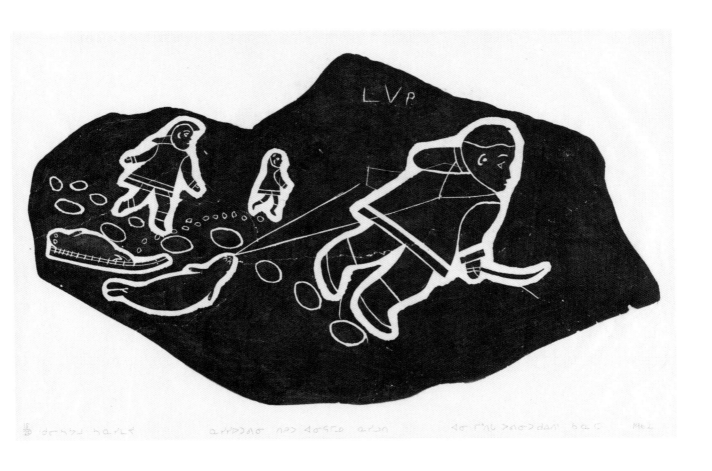

PLATE 13

Top to bottom, from left:

Snow knife
Thule culture
Iglulik (Igloolik) vicinity
Bone, stone, 9.9 × 3.2 × 1.6 cm
PM 64-34-10/43972

Pendant
Thule culture
Hudson Bay region
Ivory, 1.5 × 0.9 × 0.9 cm
PM 65-7-10/44115

Needle
Thule culture
Iglulik (Igloolik) vicinity
Ivory, 3.3 × 0.2 × 0.1 cm
PM 62-3-10/39706A

Woman's knife handle
Thule culture
Hudson Bay region
Ivory, 6.2 × 2.3 × 2.2 cm
PM 65-7-10/44113

Harpoon head
Dorset culture
Hudson Bay region
Ivory, 8.4 × 1.7 × 1.4 cm
PM 65-7-10/44112

Harpoon head
Early Thule or late Dorset
culture (?)
Iglulik (Igloolik) vicinity
Bone, 8.3 × 2 × 1.1 cm
PM 62-3-10/39707

THE SIX OBJECTS PICTURED HERE, which Chauncey Nash obtained from Brother Jacques Volant, were common hunting implements and household items used by the forerunners of the modern Inuit. The Dorset people, long known for their beautiful art forms, as a rule did not decorate their utilitarian objects. Yet their crafts-manship suggests a technical and artistic skill that they could easily have applied to carved objects serving a host of other functions, from personal adornment to magico-religious rituals. According to Arctic archaeologist Robert McGhee, the meaning of much of Dorset art, such as exact miniature replicas of harpoon heads, will always remain a mystery.[87]

The Thule people, whose purely sculptural forms were fewer, simpler, and more standardized than those of the Dorset, did often add simple decorations to their ivory objects, especially to harpoon heads and other weapons used in hunting marine mammals and to combs and other objects associated with women.[88]

Several of the dozen or so archaeological objects in the Nash collection, includ-ing three on this page, came from Iglulik, where Father Guy Mary-Rousselière, one of Volant's fellow Oblate missionaries, conducted extensive research among the Inuit and helped Volant build his collection at the Eskimo Museum. (Opposite: 98830023. Mark Craig, photographer.)

91

BEFORE THE ESTABLISHMENT of the Povungnituk Co-operative Association and the introduction of printmaking to the community in 1961, Puvirnituq Inuit produced and sold carvings directly to the Hudson's Bay Company or through a cooperative group called the Sculptors' Society of Povungnituk, founded by Father André Steinmann, OMI, the resident Roman Catholic missionary.

This robust narrative carving from Puvirnituq is one of several in the Nash collection that portrays vividly the life of the coastal Inuit hunter. The incised lines and other markings on the dark gray stone, a style characteristic of Puvirnituq sculpture, give definition to the piece and help accentuate detail. But as George Swinton, an artist, teacher, and early connoisseur of Inuit art, aptly noted, it is ultimately an artist's personal form, rather than a collective style, that matters and defines any work of art. Subject matter can be analyzed, wrote Swinton, but it is only when subject matter is given form by the artist that it becomes content and can be experienced and appreciated.[89] (Opposite: 98830009. Mark Craig, photographer.)

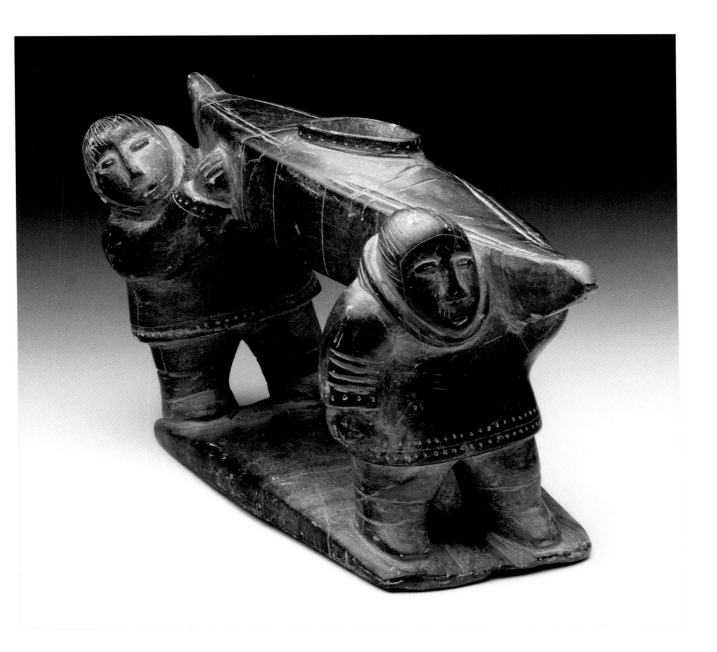

PLATE 15

Man with Speared Seal
ARTIST: Isapik Smith, 1931–1970
Sculpture, stone, ivory, leather
Puvirnituq (Povungnituk), 1958
21 × 20 × 8 cm
PM 59-14-10/38855

THE DIVERSITY OF APPROACHES that have evolved among contemporary Inuit artists can already be seen in sculptures from the 1950s and early 1960s. Although Puvirnituq style is often described as robust and realistic, it is just as common to see delicately carved and detailed figures of humans and mythological beings as it is to see action-filled hunting scenes. The difference between this carving by Isapik Smith and the preceding one (pl. 14) is striking. In plate 14 the artist draws the viewer in immediately with the detailed decorative incisions on the parkas and kayak, whereas in this smooth, unadorned piece it is the action that first catches one's eye. Through his use of balance and depiction of movement, Isapik imbued his hunter with the strength necessary to drag a seal across sea ice.

Anthropologist Nelson Graburn wrote about the Inuit concept of *nalunaikutanga*, which he interpreted as meaning the use of certain signs, symbols, markers, guides, characteristics, or distinctive features to initiate recognition or action.[90] One of the distinctive features of a traditional man's parka is its pointed hood. In this sculpture the hood draws further attention to the direction in which the man is pulling, thus endowing the sculpture with even greater movement. (Opposite: 98830022. Mark Craig, photographer.)

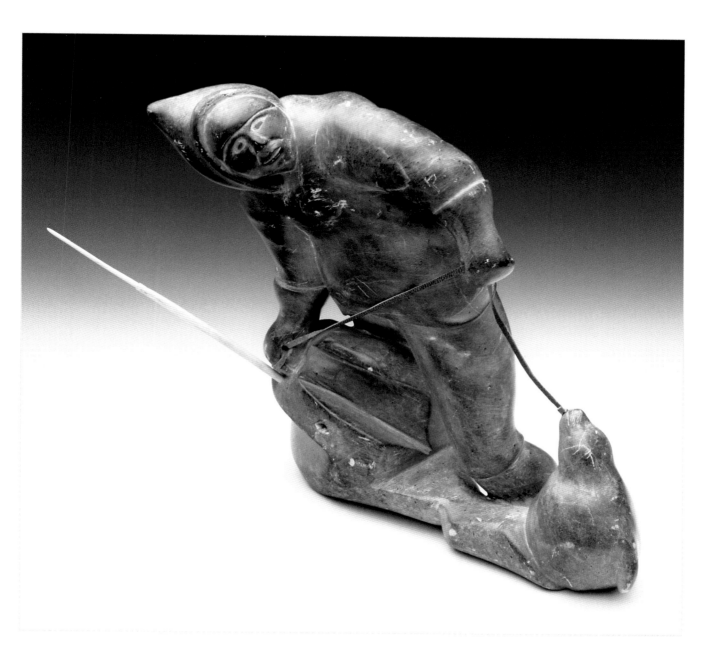

PLATE 16
Man and Walrus
ARTIST: Unidentified
Sculpture, stone, ivory(?), leather
Puvirnituq (Povungnituk), 1959
22.5 × 13 × 33 cm
PM 59-14-10/38865

IN TRADITIONAL INUIT CULTURE, before the advent of money as a medium of exchange, subsistence activities on both land and sea enabled people to survive and provide for their families. A skilled hunter was a highly valued member of a family and community. Tales abound of the hardships endured by women whose husbands died suddenly, often while hunting, leaving their wives and children with no way to meet their daily needs.

The strong connection between man and animal is especially evident in this sculpture, in which the two forms become almost one as the man and his prey come face to face. By emphasizing the massive boots and bulky parka, the artist pits the strength required of the hunter against that of the formidable walrus. Although this sculpture and the one by Isapik (pl. 15) portray similar activities and were created by artists from the same community, the differences between the two are striking. The incised detail found on both man and walrus draws immediate attention to the robust figures themselves, whereas in Isapik's piece it is the act of pulling that stands out. (Opposite: 98830021. Mark Craig, photographer.)

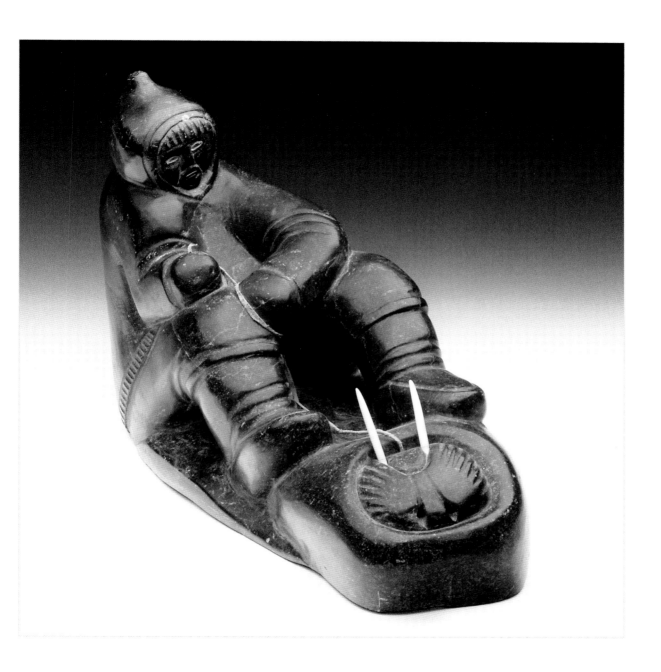

PLATE 17

Dog
ARTIST: Johnniebo Ashevak,
1923–1972
Sculpture, stone
Kinngait (Cape Dorset), 1959
11 × 16.5 × 10.5 cm
PM 59-14-10/38873

JOHNNIEBO ASHEVAK, WHOSE FOREBEARS CAME from the Panniqtuuq area
of Baffin Island, was married to the renowned graphic artist Kenojuak Ashevak (see
pl. 1 and illustration on p. 47). Both Johnniebo and Kenojuak carved as early as the
mid–1950s, especially at times when hunting was difficult and the already flounder-
ing fur trade proved unreliable. Before the West Baffin Eskimo Co-operative was
established in 1959, they sold their carvings to the Hudson's Bay Company. Johnniebo
also made drawings and copperplate engravings; more than twenty of his images were
released in Kinngait annual print collections.[91]

As Kenojuak's reputation grew, she and Johnniebo had several opportunities to
travel together to events honoring their work. Among other events, they attended the
opening of an exhibit at the National Library of Canada and the ceremony in which
Kenojuak received the Order of Canada medal. In 1969 Kenojuak and Johnniebo,
accompanied by three of their children, spent several months in Ottawa, carving a
composite image drawn by Kenojuak into a plaster mural for the Canadian Pavilion at
Expo '70 in Osaka, Japan. Unfortunately, Johnniebo died without seeing the exhibit
Sculpture by Kenojuak and Johnniebo, in Halifax, Nova Scotia, which featured about
sixty of their drawings, prints, and sculptures.

The vibrant green of the sculptures on these two pages represents just one of
many shades of green stone used by southern Baffin Island artists. The color and
hardness of the stone vary depending on the combination of minerals present.
(Opposite: 98830026; below left: 98830027; below right: 98830014. Mark Craig,
photographer.)

Johnniebo Ashevak (1923–1972),
Sea Goddess. Stone sculpture,
Kinngait (Cape Dorset), c. 1960.
6.9 × 28.7 × 7 cm. PM 60-48-10/
39075.

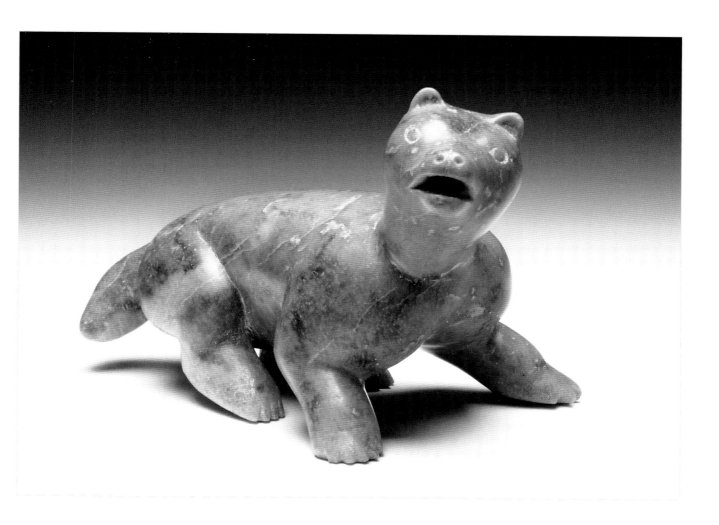

PLATE 18

Walrus
ARTIST: Unidentified
Sculpture, stone, bone(?)
Kimmirut (Lake Harbour),
c. 1965
11.5 × 17.5 × 10 cm
PM 65-7-10/44037

THE MOTTLED COLORATION of this highly polished sculpture resulted from changes in the chemical composition of the rock—changes of a sort often caused by a reaction with the chemical properties of other rocks when stones are kept moist by precipitation. Both Kimmirut and Kinngait are known for the varied hues of their stone materials and for the sculptures made from them, representing animals and mythological beings. Procuring this beautiful stone, however, has always been difficult and dangerous. People have been injured and even killed at quarry sites from hazards such as collapsing overhangs. Inuit artists continue to seek safer and more effective ways to obtain stone.

The Nash sculpture collection contains numerous representations of animals and other wildlife carved in stone. Some, such as those from Puvirnituq (pls. 15, 16, and see illustration on p. 61), take the form of action-filled scenes. In other portrayals, such as this walrus, the artist concentrated solely on the physical characteristics—even the personality—of the animal itself. (Opposite: 98830030. Mark Craig, photographer.)

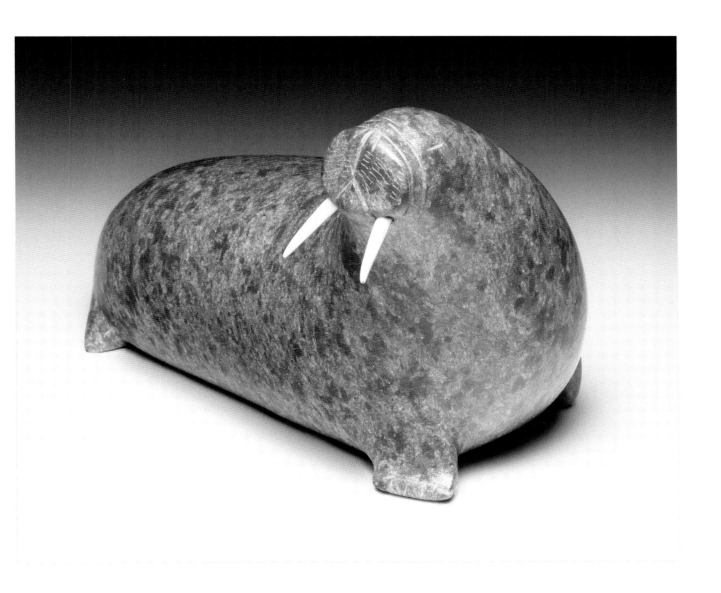

PLATE 19

Seated Man
ARTIST: John Kavik, 1897–1993
Sculpture, stone
Kangiqliniq (Rankin Inlet),
c. 1966
18 × 15.2 × 9 cm
PM 66-25-10/44173

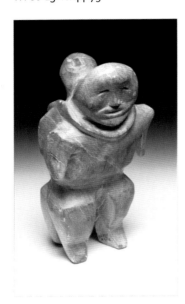

John Kavik (1897–1993), *Woman Carrying a Child*. Stone sculpture, Kangiqliniq (Rankin Inlet), c. 1966. 22 × 7.5 × 6.5 cm. PM 66-25-10/44172.

JOHN KAVIK, ONE OF THE BEST-KNOWN ARTISTS from Kangiqliniq, began carving shortly after relocating to this mining community with his family in 1959. The North Rankin Nickel Mine, which operated from 1957 until 1962 and employed Inuit from all over the region, also served as a ready source of carving stone until its supply was depleted, requiring carvers to make trips farther away. Kavik was born in Uqsuqtuuq (Gjoa Haven) in 1897 and spent a large part of his life as a hunter and fisherman. In Kangiqliniq he received encouragement and recognition early in his artistic career from Robert Williamson, an anthropologist who was based there at the time, and from the artist George Swinton. Years later Williamson recalled Kavik as a man with a vivid imagination, an inquisitive mind, a love of life, and a sense of humor.[92]

Kavik is known primarily for his rough, unadorned, unpolished depictions of the human form—bold and dignified renderings with just a hint of mystery. What is the seated man on the opposite page holding or doing? What is the woman shown on this page thinking? What emotion is her facial expression meant to convey? Kavik's son, Thomas Ugjuk, himself a noted sculptor, spoke of Kavik's vivid imagination and the satisfaction he took from being able to express an idea in a carving, even if the carving was not particularly well formed or pleasing to look at.[93] Thomas was proud of his father's work and believed that Kavik's spirit would come back to live in other Inuit even after his death.[94]

John Kavik's work has been shown in many exhibitions, including the landmark *Sculpture/Inuit* exhibit of 1971–1973, which toured the world and gave many Inuit artists the recognition they deserved. Although best known for his stone sculptures, Kavik worked in several other media as well and was a major participant in the Rankin Inlet Ceramics Project. This experiment in pottery making, which lasted more than ten years, was introduced in Kangiqliniq in 1963 by the Canadian government. Artists working in clay produced many outstanding and interesting pieces that were conceived of as sculptures rather than as functional vessels. Ceramic art production has seen a revival in the community since the early 1990s. (Opposite: 98830010; left: 98830011. Mark Craig, photographer.)

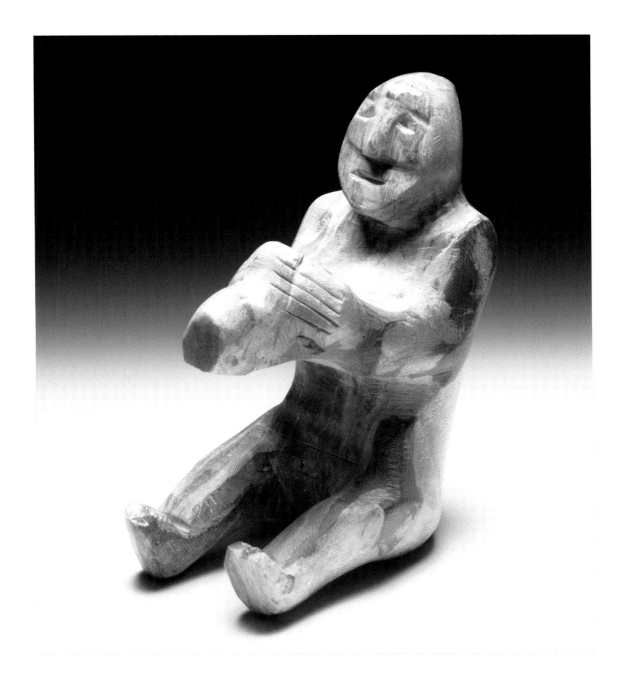

PLATE 20
Stone sculptures
of heads and faces

Facing page, left to right:
ARTIST: Unidentified
Hudson Bay region, c. 1964
8.5 × 6.1 × 6.4 cm
PM 64-34-10/43966

ARTIST: Laurent Aksadjuak,
1935–2002
Kangiqliniq (Rankin Inlet),
c. 1965
Signed with syllabics and disc
number (E1-17)
11.6 × 7.3 × 3.6 cm
PM 65-7-10/44106

This page, left to right:
ARTIST: Apollina Nobvak,
1906–1965
Naujaat (Repulse Bay), c. 1964
21 × 13.4 × 4.3 cm
PM 64-34-10/43933

ARTIST: Joseph Angatajuak,
1935–1976
Kangiqliniq (Rankin Inlet), c. 1965
Signed with syllabics and disc
number (E1-486)
17 × 11.1 × 4.5 cm
PM 65-7-10/44105

ARTIST: Unidentified
Qausuittuq (Resolute), c. 1960
18.5 × 14.6 × 4.2 cm
PM 60-48-10/39064

DEPICTION OF THE HUMAN HEAD AND FACE, which can be traced back to Dorset times in the Canadian Arctic, takes many forms in contemporary Inuit sculpture. Faces and heads can appear singly, in pairs, or as groupings and are found in a variety of media, such as stone, bone, and ceramic.[95] The stone pieces from the Nash collection pictured here range from examples with barely discernable features to detailed forms such as the head by Apollina Nobvak, with its carefully incised and symmetrical tattoo marks. Donor notes accompanying this piece suggest that it carries a transformative or spiritual connotation. The piece from Qausuittuq, which takes the form of a mask and is similarly tattooed, is somewhat reminiscent in both shape and expression of prehistoric masks. It is not unlike the famous Tyara mask from the early Dorset period, a miniature ivory mask (3.5 cm in its longest dimension) that was excavated in the late 1950s from the Tyara archaeological site on the south shore of Hudson Strait.

Although stand-alone depictions of human heads and faces are rare in Inuit graphic art, one of three images by Jessie Oonark of Qamanittuaq (pl. 10) that were released as prints at Kinngait was *Tatooed [sic] Faces*, a linear arrangement of seven decorated faces, each varying slightly from the others. In *People of the Inland*, another of the three prints and part of the Nash collection, Oonark drew a similar face but extended it into a full female figure dressed in traditional garb. (Opposite: 98830018; below: 98830019. Mark Craig, photographer.)

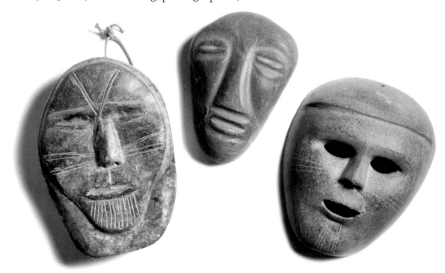

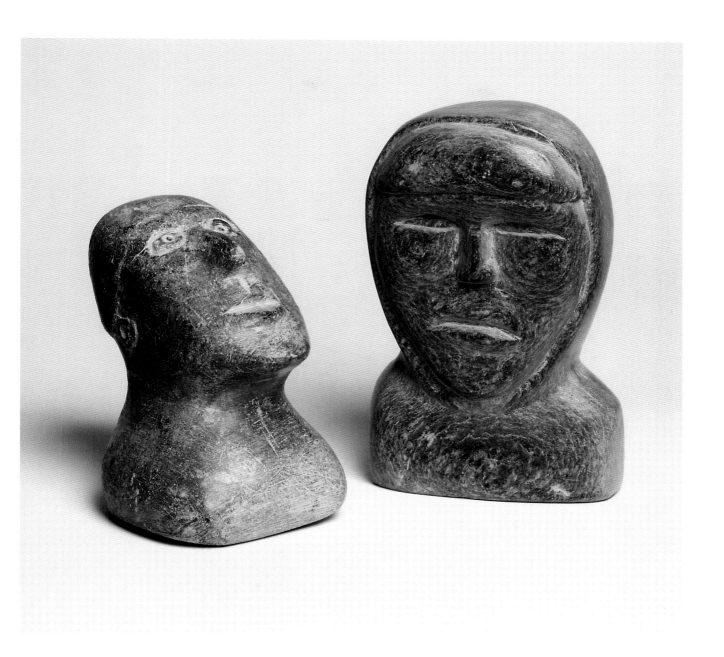

PLATE 21

Ivory and mixed media miniatures

Clockwise from top left:
Caribou
ARTIST: Unidentified
Ivory
Qausuittuq (Resolute), c. 1958
6.1 × 11 × 4 cm
PM 59-14-10/38872

Scene with mother and child
ARTIST: Unidentified
Stone, bone, ivory
Kugaaruk (Pelly Bay), c. 1964
17.4 × 6.5 × 4.9 cm
PM 64-34-10/43947

Birds
ARTIST: Gita Tireatnar Inuksaq
Ivory, stone, antler
Kugaaruk (Pelly Bay), c. 1966
Signed Gita Threse
8.9 × 3 × 2.7 cm
PM 66-25-10/45465

Man and seal
ARTIST: Unidentified
Ivory
Kugaaruk (Pelly Bay), c. 1966
7 × 3.3 × 3.5 cm
PM 66-25-10/45463

VISITORS TO THE CANADIAN ARCTIC in the nineteenth and early twentieth centuries were familiar with and often collected the small ivory figures that the Inuit had begun to produce specifically in response to the growing influx of traders, whalers, explorers, and others to the area. These tiny objects, taken from the daily lives of the Inuit, represented animals and birds, hunting equipment, clothing, and means of transportation, as well as items introduced by non-Inuit people, such as carpenter's tools, rifles, and cutlery. Such sculptures became important to the Inuit economy as items made for trading or for sale, both by commission and on speculation. They appealed strongly to non-Inuit residents of the Arctic for their exquisite craftsmanship and as mementos of time spent in the region. One notable collection, residing at the Royal Ontario Museum, is that of Jon Bildfell, a physician stationed in the Baffin Island community of Panniqtuuq in the 1930s and again in the 1940s.[96]

Ivory carvings from the historic period help link the past with contemporary Inuit art. Artists from the northwest coast of Hudson Bay, especially the communities of Kugaaruk and Naujaat, have been particularly well known for carving these small figures since the late nineteenth century. They have continued making ivory miniatures and mixed-media tableaux to the present day. (Opposite: 98830012. Mark Craig, photographer.)

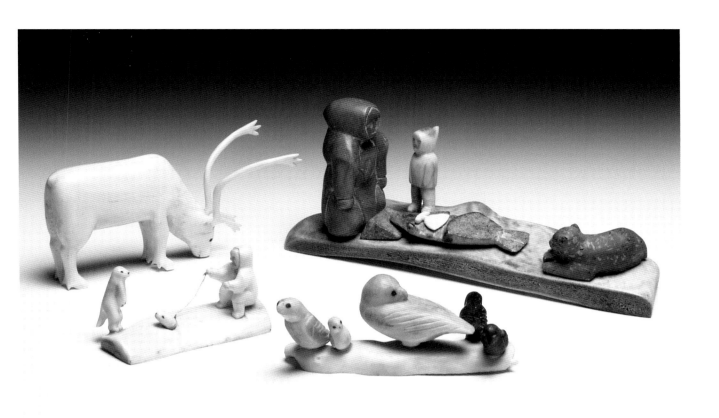

PLATE 22

Drummer
Artist: Unidentified
Sculpture, ivory miniature
Kugaaruk (Pelly Bay), c. 1964
5.2 × 1.6 × 3.4 cm
PM 64-34-10/43950

The singer stands in the middle of the floor, with knees slightly bent, the upper part of the body bowed slightly forward, swaying from the hips, and rising and sinking from the knees with a rhythmic movement, keeping time throughout with his own beating of the drum. Then he begins to sing, keeping his eyes shut all the time; for a singer and a poet must always look inward in thought, concentrating on his own emotion. —Knud Rasmussen, *Intellectual Culture of the Iglulik Eskimos*

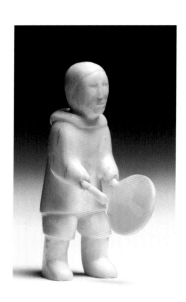

TRADITIONALLY, PEOPLE THROUGHOUT THE ARCTIC used some form of single-headed, shallow-frame drum, ranging from one to three feet in diameter, to accompany their singing and dancing during festivals and celebrations. In the western Arctic, which had a complex ceremonial structure, drum dances usually involved a group of drummer-singers. In the eastern Arctic, it was the solo drummer-dancer who took center stage. A drum dance might be held for any number of reasons, such as maintaining good relations with the spirit world, celebrating a successful hunt, welcoming visitors, and reaffirming cultural values. The drum played a crucial role in shamanistic performances, and in Greenland—as well as parts of Canada—drum songs were used for settling disputes.[97]

This miniature ivory drummer from Kugaaruk, seen in two views, is one of countless representations of this important figure in Inuit culture found in a variety of media (see also pl. 23). The context of drum dancing has changed over time; today it takes place primarily during public performances—at opening ceremonies for important gatherings such as conferences, as parts of local and regional festivals, or for visiting dignitaries or tourists. Nevertheless, the drum and the songs connected to it remain vital links with the past. (Opposite: 98830016; left: 98830015. Mark Craig, photographer.)

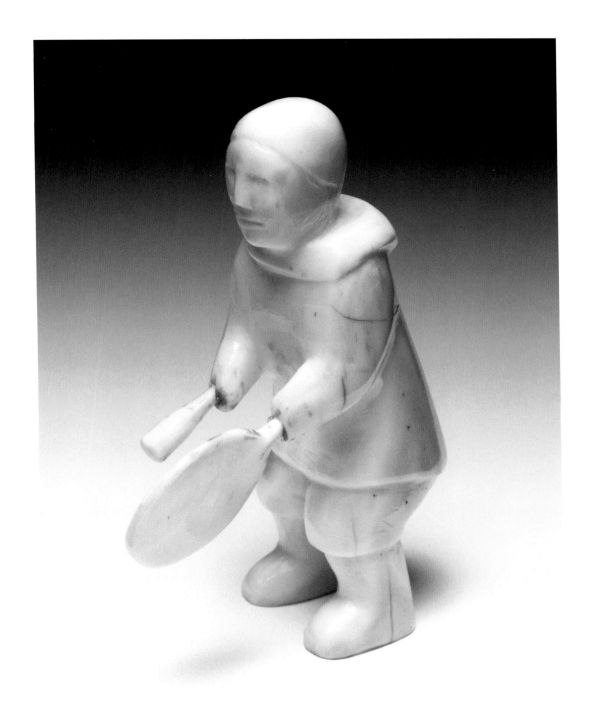

PLATE 23
Dance Scene
Artist: Unidentified
Sculpture, stone, bone
Naujaat (Repulse Bay)(?), c. 1965
9.5 × 13 × 10 cm
PM 65-7-10/44100

THE EXPLORER KNUD RASMUSSEN, in his detailed descriptions of Inuit song festivals, wrote about the rules and conventions that the Inuit followed during performances and about the strength and stamina required of the singer–drummer during festivals that could last for fourteen hours or more. Before a performance, the drum had to be tuned by moistening and stretching it to obtain the required sound. Each singer had to begin by expressing modesty about his own songs in order to gain favor from the audience. And each lead singer had to sing a certain number of songs lest he be considered a poor or inexperienced singer.

But it was the emotionally charged atmosphere of the event, as the performers skillfully coordinated their body movements, bending their knees and singing the melody to the beat of the drum, that most impressed Rasmussen. It made him wish for a technology with which to capture the experience for others—a technology unavailable to him in the Arctic in the early 1920s.[98]

In the dance scene shown on the opposite page, the figures facing the drummer may well represent the state of collective ecstasy brought on by the drummer and his performance. (Opposite: 98830024; left: 98830025. Mark Craig, photographer.)

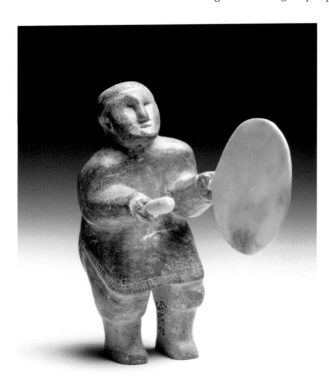

Unidentified artist, *Drummer.*
Stone and bone sculpture, Naujaat
(Repulse Bay), c. 1961. 12 × 5 × 10.5
cm. PM 61-22-10/39115.

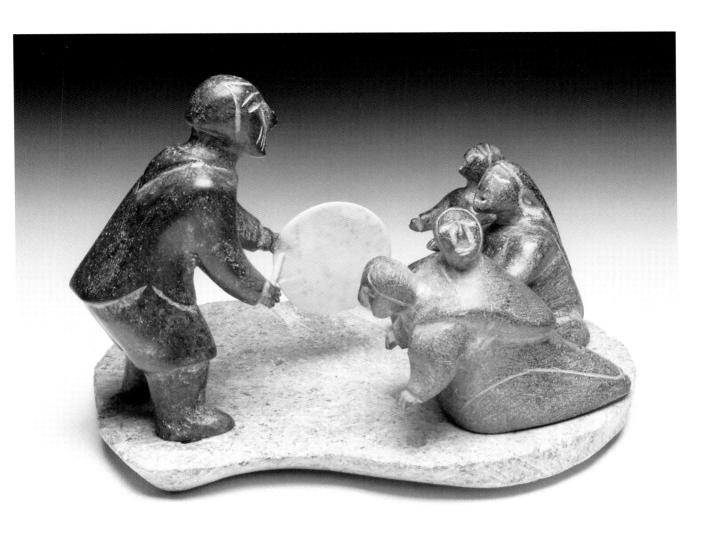

PLATE 24
Sculptures of owls

Left to right:
ARTIST: Jacques Kabluitok,
1909–1970
Stone
Kangiqliniq (Rankin Inlet), c. 1965
Signed with syllabics and disc
number (E3-85)
16 × 7.5 × 11 cm
PM 65-7-10/44107

ARTIST: Unidentified
Stone, shell(?)
Naujaat (Repulse Bay), c. 1960
8.8 × 4.5 × 5.1 cm
PM 60-48-10/39065

ARTIST: Jimmy Arnamissak,
1946–2003
Stone, shell
Inukjuak (Port Harrison), 1959
Signed "Jimmy" and with disc
number (E9-395)
11.8 × 13.2 × 8.5 cm
PM 62-3-10/39150

ARTIST: Jimmy Arnamissak,
1946–2003
Stone
Puvirnituq (Povungnituk), c. 1961
Signed with disc number
(E9-395)[99]
14 × 7.5 × 9 cm
PM 62-3-10/39149

ARTIST: Unidentified
Stone, shell
Naujaat (Repulse Bay), c. 1965
11 × 5.1 × 8.5 cm
PM 65-7-10/44040

BIRDS HAVE ALWAYS PLAYED a prominent role in Inuit life and mythology. Gulls, ravens, loons, owls, ptarmigans, buntings, geese, and crows are all well represented in the large corpus of Arctic folk tales recorded by explorers and anthropologists such as Knud Rasmussen and Franz Boas. Often, versions of tales vary throughout the Arctic, as in the well-known story of the man who married a goose and, after she flew away from him, went looking for her in the land of the birds, meeting many obstacles along the way.[100]

Birds have provided Inuit artists with popular subject matter, and none more so than the owl. Treatments of owls in both prints and sculptures have ranged from Kenojuak's many colorful, fantastic depictions and humorous or whimsical renderings such as the one by Lucy shown on this page to the variety of carved pieces with unique expressions and characteristics seen on the opposite page. (Opposite: 98830029; below left: 98810023; below right: 98810022. Mark Craig, photographer.)

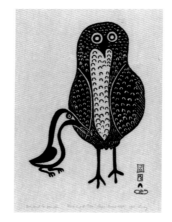 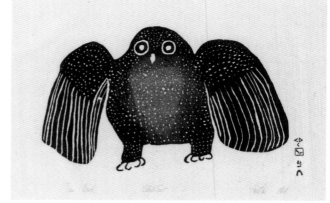

Lucy Qinnuayuak (1915–1982), *Owl and Companion.* Stonecut printed by Lukta Qiatsuq, Kinngait (Cape Dorset), 1961. 15/50. 53 × 39.7 cm. PM 62-3-10/40697.

Pauta Saila (1916–2009), *Owl.* Stonecut printed by Echalook Pingwartok, Kinngait (Cape Dorset), 1964–1965. 7/50. 54.9 × 70.2 cm. PM 66-25-10/44166.

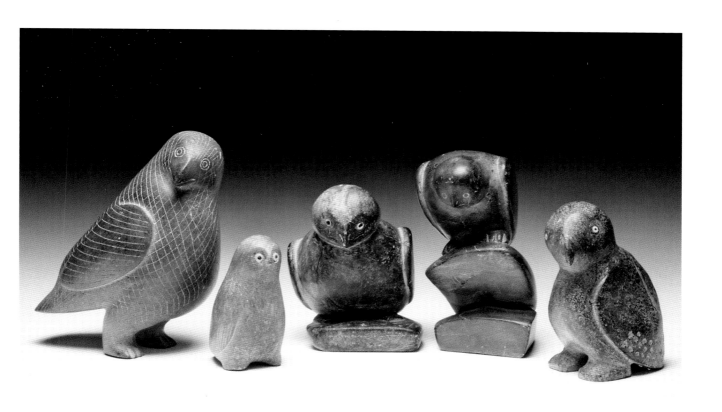

PLATE 25

Man Hunting Seal
ARTIST: Mark Tungilik, 1913–1986
Sculpture, stone, ivory, sinew
Naujaat (Repulse Bay), c. 1963
21 × 5 × 11 cm
PM 64-34-10/43935

MARK TUNGILIK, WHO WAS BORN in the Kugaaruk area but later moved to Naujaat, is known primarily for his ivory miniatures—strong and expressive figures of people, animals, and spirits—which he continued to produce until his death, in spite of failing eyesight. In 1945, at the request of Father Franz Van de Velde, the resident Oblate missionary in Kugaaruk, he carved the first of several Christian "spirit" pieces, one of which was presented to Pope Pius XII in 1948.[101]

The seal hunter on the opposite page is a larger work by Tungilik that is reminiscent of his earliest carvings of human figures in stone. Many of the same facial features found in his ivory carvings can be seen on this hunter, who waits patiently on the ice, perhaps in driving snow and biting wind, for a seal to appear at a blowhole, one of several the seal may have opened in order to come up to breathe. Depending on the thickness of the ice, it could take several hours for the hunter to find the hole and again as many, or even more, for the seal to appear. (Opposite: 98830029. Mark Craig, photographer.)

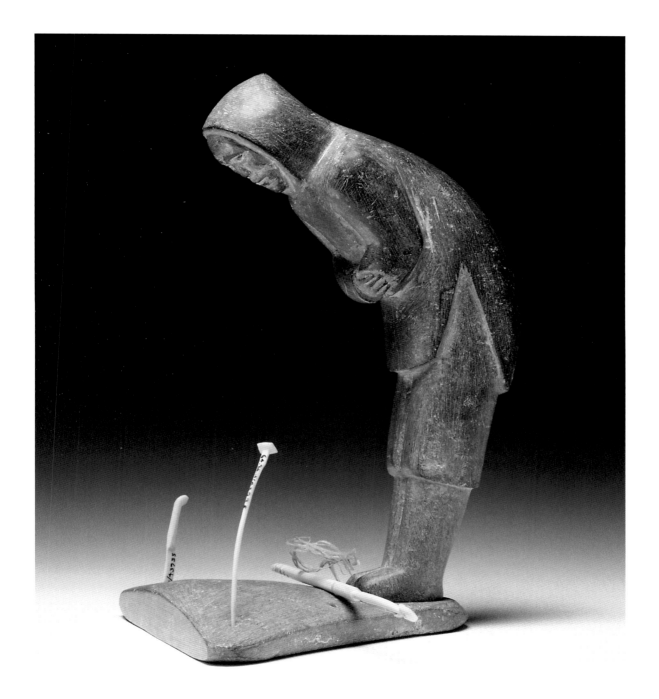

Notes

1. For an autobiographical account of Houston's years in the Arctic, see James Houston, *Confessions of an Igloo Dweller* (Boston: Houghton Mifflin, 1995). See also "James Houston, 1921–2005," *Inuit Art Quarterly*, special supplement to vol. 20, no. 2 (2005).

2. This piece, which Comer donated to the American Museum of Natural History, belies the widely held notion that all carvings in the historic period were small. George Swinton, *Sculpture of the Inuit*, third edition (Toronto: McClelland and Stewart, 1999), 122.

3. See Charles A. Martijn, "A Retrospective Glance at Canadian Eskimo Carving," *The Beaver* (Autumn 1967): 4–19; William E. Taylor Jr. and George Swinton, "Prehistoric Dorset Art," *The Beaver* (Autumn 1967): 32–47; Robert McGhee, "The Prehistory and Prehistoric Art of the Canadian Inuit," *The Beaver* (Summer 1981): 23–30. See also Robert McGhee, "Prehistoric Arctic Peoples and Their Art," *Inuit Art Quarterly* 14, no. 4 (1999). This is a revised and updated version of an article that first appeared in 1986 in the *American Review of Canadian Studies*.

4. For a recent look at the rich and multilayered history of the Arctic region, including theories about the complex relationship between the Thule and Dorset peoples, see Robert

McGhee, *The Last Imaginary Place: A Human History of the Arctic World* (Toronto: Key Porter Books, 2004).

5. Toggles were used for many purposes, a common one being as an attachment to a seal-hauling line. The toggle, which often took the form of a seal, was inserted into the animal's lower jaw.

6. McGhee, "Prehistoric Arctic Peoples," 18–19.

7. J. C. H. King, "Clothing Portraits: Identity and Meaning in Inuit Figure Studies from the Eastern Arctic," in *Arctic Clothing of North America—Alaska, Canada, Greenland* (Montreal: McGill-Queen's University Press, 2005), 142–143.

8. Stephen Loring, "Hunters of the Hunter's World: Some Reflections on Innu and Inuit Drawings in the National Anthropological Archives," *American Indian Art* (Winter 2000): 78–81.

9. For the story of the origin of modern Inuit printmaking as recounted by Houston himself, see James Houston, *Eskimo Prints* (Barre, Mass.: Barre Publishers, 1971), 9–31.

10. For a discussion of the origin and transnational history of Japanese woodblock printmaking, a detailed account of the three months Houston spent learning from Japanese artists, and ways in which Japanese printmaking influenced the Inuit print, see Norman Vorano, *Inuit Prints, Japanese Inspiration* (Gatineau, Quebec: Canadian Museum of Civilization Corporation, 2011).

11. E-mail communication from Leslie Boyd Ryan, December 9, 2010. See also Terry Ryan, "A Response to the Japanese Printmakers," *Inuit Art Quarterly* 1, no. 2 (1986): 4.

12. Patricia Feheley, "Terry Ryan: A Visionary with a Pragmatic Edge," *Inuit Art Quarterly* 24, no. 1 (2009): 10–19; 24, no. 2 (2009): 14–23.

13. Houston, *Confessions of an Igloo Dweller*, 157–161.

14. Anne Newlands, *Canadian Art: From Its Beginnings to 2000* (Willowdale, Ont.: Firefly, 2000).

15. For further discussion of the history and development of contemporary Inuit art in the western Arctic, see Janet Catherine Berlo, "An Introduction to the Arts of the Western Arctic," *Inuit Art Quarterly* 10, no. 3 (1995): 15–21, and Janet Catherine Berlo, "Drawing and Printmaking at Holman," *Inuit Art Quarterly* 10, no. 3 (1995): 22–30.

16. See Swinton, *Sculpture of the Inuit*, chapters 7–9, for a discussion of arguments and controversies revolving around Inuit art. See also Charles A. Martijn, "Canadian Eskimo Carving in Historical Perspective," *Anthropos* 59, nos. 3–4 (1964): 546–596.

17. E-mail communication from Leslie Boyd Ryan, December 9, 2010. For a discussion of

some new directions in which Inuit art is going, see Robert Kardosh, "The New Generation: A Radical Defiance," *Inuit Art Quarterly* 23, no. 4 (2008): 20–30.

18. In addition to publishing *Inuit Art Quarterly*, the Inuit Art Foundation produced several online art histories, including "Inuit Art Alive" (http://www.inuitartalive.ca), "Nunavik Art Alive" (http://www.inuitart.org/exhibitions/nunavikartalive), and "Inukjuak Art History" (search "Inukjuak" at http://www.virtualmuseum.ca). These sources include displays of artworks, articles about art making, artist profiles, artist interviews, and videos. To honor the establishment of the new territory of Nunavut in 1999, the National Film Board of Canada produced a sixty-video set titled "In Celebration of Nunavut." See http://www.onf-nfb.gc.ca for the contents of this collection of more than one hundred films made between 1942 and 1996. The five-video subset called "Inuit Arts" includes the now-classic films *The Living Stone* (1958) and *Eskimo Artist: Kenojuak* (1963), both of which can be viewed online. The twenty-fifth anniversary issue of *Inuit Art Quarterly* (vol. 26, no. 1, Spring 2011) gives an overview of the myriad topics and issues that the magazine has covered since its inception, from training, marketing, and new media to women's art.

19. James Houston, "To Find Life in the Stone," in *Sculpture of the Inuit: Masterworks of the Canadian Arctic* (Toronto: University of Toronto Press, 1971), 56.

20. *First Annual Report of the Trustees of the Peabody Museum of American Archaeology and Ethnology* (Cambridge, Mass.: Peabody Museum, 1868), 26–27.

21. See J. O. Brew, *People and Projects of the Peabody Museum, 1866–1966* (Cambridge, Mass.: Peabody Museum Press, 1966), and J. O. Brew, *Early Days of the Peabody Museum at Harvard University* (Cambridge, Mass.: Peabody Museum Press, 1966).

22. Brew, *Early Days*, 11–12. See also Christopher S. Johnson, "Written, Printed, and Bound by the Esquimaux," *Harvard Magazine,* February 1975. This first volume of *Kaladlit Okalluktualliait,* printed in 1859, appears not actually to have been the earliest publication in Greenland. It was preceded two years earlier by a popular and now scarce little book known as the *Pok* book, as well as by a book of psalms printed as early as 1793 by a missionary who brought a primitive printing press to Greenland from Germany. See Kenn Harper, "The Passing of Lars Møller, Greenland's Printer [January 21, 1926]," *Taissumani,* January 20, 2006 (www.nunatsiaqonline.ca), and Bodil Kaalund, *The Art of Greenland: Sculpture, Crafts, Painting,* translated by Kenneth Tindall (Berkeley: University of California Press, 1983), 164–171.

23. *Twenty-sixth Annual Report of the Peabody Museum of American Archaeology and Ethnology* (Cambridge, Mass.: Peabody Museum, 1892), 1–2.

24. *Guide to the Peabody Museum of Harvard University with a Statement Relating to Instruction in Anthropology* (Salem, Mass.: Salem Press, 1898), 8, 23–24.

25. *Thirty-seventh Annual Report of the Peabody Museum of American Archaeology and Ethnology* (Cambridge, Mass.: Peabody Museum, 1903), 1.

26. Vilhjalmur Stefansson, *Discovery* (New York: McGraw-Hill, 1964), 40–62.

27. Brew, *People and Projects*, 31, 38.

28. Ibid., 20.

29. Christraud M. Geary, "On Collectors, Exhibitions, and Photographs of African Art: The Teel Collection in Historical Perspective," in *Art of the Senses: African Masterpieces from the Teel Collection*, edited by Suzanne Preston Blier (Boston: MFA Publications, 2004), 28–30.

30. W. Jackson Rushing, "Marketing the Affinity of the Primitive and the Modern: René d'Harnoncourt and 'Indian Art of the United States,'" in *The Early Years of Native American Art History: The Politics of Scholarship and Collecting*, edited by Janet Catherine Berlo (Seattle: University of Washington Press, 1992), 191–236.

31. See *Masterpieces of Primitive Art* (Boston: Museum of Fine Arts, 1958), and Geary, "On Collectors," 34–35.

32. *Ninety-third Annual Report of the Peabody Museum of Archaeology and Ethnology* (Cambridge, Mass.: Peabody Museum, 1959), 492–493.

33. Biographical information about Chauncey Nash and his family is drawn primarily from L. Vernon Briggs, *History and Genealogy of the Briggs Family, 1254–1937* (Boston: Priv. print., Charles E. Goodspeed, 1938); L. Vernon Briggs, *History of Shipbuilding on North River, Plymouth County, Massachusetts* (Boston: Coburn Brothers, 1889); James Eugene Mooney, "Chauncey Cushing Nash [Obituary]," *Proceedings of the American Antiquarian Society* 78, pt. 2 (Worcester, Mass.: The Society, 1969), 230–232; anniversary reports of the Harvard class of 1907; and personal communication with Chandler Gifford Jr.

34. *The Harvard Class Album*, 1907, 132.

35. Harvard College, student records 1876–1982, undergraduates, classes of 1887–1909. Microfilm, Harvard University Archives, UAIII 15.75.10 mf, Box 8.

36. Curtis M. Hinsley, "The Museum Origins of Harvard Anthropology, 1866–1915," in *Science at Harvard University: Historical Perspectives*, edited by Clark A. Elliott and Margaret W. Rossiter (Bethlehem, Pa.: Lehigh University Press, 1992), 134.

37. Lawrence C. Wroth, *The Walpole Society: Five Decades* (n.p.: Walpole Society, 1960), 29.

38. Wallace Nutting, *Furniture of the Pilgrim Century, 1620–1720* (Framingham, Mass.: Old America Company, 1921), 314.

39. Chauncey Cushing Nash, *John Warner Barber and His Books* (Milton, Mass.: n.p., 1934). Reprinted from the *Note Book of the Walpole Society*, 1934.

40. Statements attributed to Chandler Gifford Jr. were obtained during interviews and telephone conversations in 2008–2009.

41. Lorraine E. Brandson, *Carved From the Land: The Eskimo Museum Collection* (Churchill, Manitoba: Diocese of Churchill Hudson Bay, 1994), 9–21.

42. A short announcement and review of the 1961 exhibit of Inuit prints at Boston's Museum of Science, accompanied by three photographs, appeared in the March 28, 1961, edition of the *Christian Science Monitor*.

43. Beekman H. Pool, *The Chauncey C. Nash Collection: Contemporary Canadian Eskimo Art* (Boston: Club of Odd Volumes, 1964).

44. The following accession files of the Peabody Museum provided Chauncey Nash's correspondence and other valuable information concerning the collection: 59-14, 60-48, 61-22, 62-3, 64-34, 65-7, 66-25, 967-72.

45. Maria von Finckenstein, "The Art of Survival," in *Hidden in Plain Sight: Contributions of Aboriginal Peoples to Canadian Identity and Culture*, edited by David R. Newhouse, Cora J. Voyageur, and Dan Beavon (Toronto: University of Toronto Press, 2005), 84.

46. Ibid., 85.

47. West Baffin Eskimo Co-operative, *Dorset 76: Cape Dorset Annual Graphics Collection 1976* (Toronto: M. F. Feheley, 1976), 9.

48. Derek Norton and Nigel Reading, *Cape Dorset Sculpture* (Vancouver: Douglas and McIntyre, 2005), 25.

49. Janet Catherine Berlo, "Portraits of Dispossession in Plains Indian and Inuit Graphic Arts," *Art Journal* 49, no. 2 (1990): 138–140.

50. Information about printmaking techniques in Kinngait is drawn from Linda Sutherland, "The Printmaking Process at Cape Dorset: A Technical Guide," in *In Cape Dorset We Do It This Way: Three Decades of Inuit Printmaking*, by Jean Blodgett (Kleinburg, Ont.: McMichael Canadian Art Collection, 1991), 37–42.

51. Blodgett, *In Cape Dorset We Do It This Way*, 9, 29–36.

52. Jean Blodgett, *Kenojuak* (Toronto: Firefly Books, 1985), 75.

53. West Baffin Eskimo Co-operative, *Dorset 83: Cape Dorset Twenty-fifth Graphics Annual* (Toronto: Methuen, 1983), 8.

54. Robert Kardosh, "The 'Other' Kananginak Pootoogook," *Inuit Art Quarterly* 22, no. 1 (2007): 10–18.

55. Pitseolak Ashoona, *Pitseolak: Pictures Out of My Life*, drawn from interviews by Dorothy Harley Eber, second edition (Montreal: McGill-Queen's University Press, 2003), 68–70.

56. Parr's works have been exhibited in countless museums and galleries throughout Canada and the United States, among them the National Gallery of Canada, Canadian Museum of Civilization, Art Gallery of Ontario, Winnipeg Art Gallery, and McMichael Canadian Art Collection. Notable among his solo exhibitions have been *Pencil to Paper: Early Drawings by Parr,* at the National Gallery of Canada (1997); *Parr: His Drawings,* at Mount Saint Vincent University in Halifax, Nova Scotia (1988); and a retrospective exhibition of all his catalogued prints held in Toronto in 1979 to commemorate the tenth anniversary of his death.

57. Ashoona, *Pitseolak,* 4, 90.

58. Ibid., 70–72, 78.

59. Leslie Boyd Ryan, "'Mannaruluujujuq' (Not So Long Ago): The Memories of Napachie Pootoogook," *Inuit Art Quarterly* 20, no. 3 (2005): 9–16.

60. Darlene Coward Wight, *Early Masters: Inuit Sculpture 1949–1955* (Winnipeg: Winnipeg Art Gallery, 2006), 141.

61. West Baffin Eskimo Co-operative, *Dorset 78: Cape Dorset Annual Graphics Collection 1978* (Toronto: M. F. Feheley, 1978), 59.

62. West Baffin Eskimo Co-operative, *Dorset 79: Twentieth Annual Cape Dorset Graphics Collection* (Toronto: M. F. Feheley, 1979), 11.

63. Marie Routledge, *Pudlo: Thirty Years of Drawing* (Ottawa: National Gallery of Canada, 1990), 16–18.

64. Ibid., 18, 77.

65. West Baffin Eskimo Co-operative, *Dorset 83,* 14.

66. Swinton, *Sculpture of the Inuit,* 146.

67. Wight, *Early Masters,* 11–18.

68. For information on types of carving stone, physical properties of stone, and challenges faced by Inuit artists in obtaining and working with stone, I consulted Susan Gustavison, *Northern Rock: Contemporary Inuit Stone Sculpture* (Kleinburg, Ont.: McMichael Canadian Art Collection, 1999).

69. *Agreement between the Inuit of the Nunavut Settlement Area and Her Majesty the Queen in Right of Canada,* 1993, 3, 149–150.

70. Ingo Hessel, *Inuit Art: An Introduction* (Vancouver: Douglas and McIntyre, 1998), 78.

71. Ibid., 86–87; Terry Ryan, "Looking Back at Cape Dorset," in *Cape Dorset Sculpture,* by Derek Norton and Nigel Reading (Vancouver: Douglas and McIntyre, 2005), 9–10.

72. Hessel, *Inuit Art*, 96, 98–100.

73. Melanie McGrath, *The Long Exile: A Tale of Inuit Betrayal and Survival in the High Arctic* (New York: Alfred A. Knopf, 2007).

74. Blodgett, *Kenojuak*, 40.

75. Ibid., 37.

76. West Baffin Eskimo Co-operative, *1992 Cape Dorset Annual Graphics Collection* (Toronto: Dorset Fine Arts, 1992), [3].

77. West Baffin Eskimo Co-operative, *Dorset 81: Cape Dorset Graphics Annual* (Toronto: M. F. Feheley, 1981), 9.

78. West Baffin Eskimo Co-operative, *Eskimo Graphic Art 1964–65* (Cape Dorset: West Baffin Eskimo Co-operative, 1964–1965), 13.

79. Ashoona, *Pitseolak*, 43.

80. Napachie Pootoogook, interview with Odette Leroux, in *Inuit Women Artists: Voices From Cape Dorset*, edited by Odette Leroux, Marion E. Jackson, and Minnie Aodla Freeman (Hull, Quebec: Canadian Museum of Civilization, 1994), 137.

81. Leroux, Jackson, and Freeman, *Inuit Women Artists*, 74.

82. Pudlo Pudlat, interview with Marion Jackson, as edited by Marie Routledge in *Pudlo*, 15.

83. Von Finckenstein, "The Art of Survival," 67–68.

84. See Robin McGrath, "More Than Meets the Eye: The Clothing Motif in Inuit Legends and Art," *Inuit Art Quarterly* 8, no. 4 (1993): 16–23.

85. For a complete version of the Sedna myth as it was related to Boas, as well as comparisons with other versions, see Franz Boas, *The Central Eskimo*, Sixth Annual Report of the Bureau of Ethnology, 1884–1885 (Washington, D.C.: Smithsonian Institution, 1888), 583–591.

86. For a concise account of the early days of printmaking in Puvirnituq and other settlements, see Patrick Furneaux, "Evolution and Development of the Eskimo Print," in *Arts of the Eskimo: Prints*, edited by Ernst Roch (Barre, Mass.: Barre Publishers, 1975), 9–16.

87. Robert McGhee, *Ancient People of the Arctic* (Vancouver: University of British Columbia Press, 1996), 149–173.

88. McGhee, "Prehistory and Prehistoric Art of the Canadian Inuit," 28–29.

89. Swinton, *Sculpture of the Inuit*, 17–19, 142.

90. Nelson H. H. Graburn, "'Nalunaikutanga': Signs and Symbols in Canadian Inuit Art and Culture," *Polarforschung* 46, no. 1 (1976): 1–11.

91. For biographical information and a chronology of Johnniebo and Kenojuak's life together, see Blodgett, *Kenojuak*, 7–29.

92. Robert G. Williamson, "Memories of John Kavik, 1897–1993," *Inuit Art Quarterly* 8, no. 3 (1993): 46.

93. Thomas Ugjuk, "John Kavik's Son, Thomas Ugjuk, Speaks about His Father and Himself," telephone interview by Simeonie Kunnuk, July 6, 1993, *Inuit Art Quarterly* 8, no. 4 (1993): 27.

94. Williamson, "Memories," 46.

95. For a recent essay on the human face in Inuit sculpture, see Jenny McMaster, "The Face of Contemporary Inuit Sculpture: Restraint and Turmoil," in *Sanattiaqsimajut: Inuit Art from the Carleton University Art Gallery Collection*, edited by Sandra Dyck (Ottawa: Carleton University Art Gallery, 2009), 178–181.

96. Kenneth R. Lister, "Ivory Work: Inuit Representations from the Historic Period," in Dyck, *Sanattiaqsimajut*, 105–107. See also Lister, "Looking into the Eye of the Spider: Some Thoughts about Context with Reference to *Tuugaaq: Ivory Sculptures from the Eastern Canadian Arctic*," *Inuit Art Quarterly* 18, no. 3 (2003): 10–17.

97. Maija M. Lutz, "Eskimo Performance," in *Theatrical Movement: A Bibliographical Anthology*, edited by Bob Fleshman (Metuchen, N.J.: Scarecrow Press, 1986), 720–721.

98. Knud Rasmussen, *Intellectual Culture of the Iglulik Eskimos*, Report of the Fifth Thule Expedition, vol. 7, no. 1 (Copenhagen: Gyldendal, 1929), 229–230.

99. The signature with a disc number is the same on objects 62-3-10/39149 and 62-3-10/39150, so both pieces were evidently created by the same artist. That they originated in two different Nunavik communities, Puvirnituq and Inukjuak, could indicate merely the artist's movement from one community to the other or even that inaccurate information about the origin of a piece was conveyed somewhere along the way.

100. For two versions of the tale about the man who married a goose, see Boas, *Central Eskimo*, 615–618, and Rasmussen, *Intellectual Culture*, 265–267.

101. Marie Routledge and Ingo Hessel, "Contemporary Inuit Sculpture: An Approach to the Medium, the Artists, and Their Work," in *In the Shadow of the Sun: Perspectives on Contemporary Native Art* (Hull, Quebec: Canadian Museum of Civilization, 1988), 464–466.

Suggested Reading

Much has been written about Inuit art for both general readers and specialists. The following is a sample of notable publications on the topic, ranging from general overviews and exhibition catalogues to works about individual artists. The notes section of this book lists many additional books and articles for a more detailed look at Inuit art and culture.

Ashoona, Pitseolak, and Dorothy Harley Eber
2003 *Pitseolak: Pictures Out Of My Life*. Second edition. Montreal: McGill-Queen's University Press.
 First published in 1971, this book is Pitseolak's story, told in her own words, of camp life in the old days, her hopes and fears for the future, and the development of Kinngait (Cape Dorset) as an internationally recognized art center. Based on interviews conducted by Dorothy Harley Eber in 1970, it is liberally illustrated with Pitseolak's drawings and prints. A new section, added by Eber for the second edition, includes more stories about Pitseolak's life and discusses the many changes in both life and art on Baffin Island since the book was first published.

Barz, Sandra Buhai, compiler and editor

2004 *Inuit Artists Print Workbook*. Third edition. New York: Arts and Culture of the North.
 Also available online at http://www.gallery.ca. Pull down "Library and Research,"
 then "Resources," and select "Databases." Under "Databases" scroll to "Look up an
 artist" and select "Inuit Artists' Print Database/Access."
 This two-volume reference manual is a compilation of information on more
 than eight thousand Canadian Inuit prints made from 1957 to 2003, arranged by
 community and artist and presented in an easily usable and retrievable format. Barz
 examined a vast number of unpublished and published resources and conducted
 numerous interviews in order to resolve inconsistencies and supply missing data,
 especially about the early prints.

Blodgett, Jean

1991 *In Cape Dorset We Do It This Way*: *Three Decades of Inuit Printmaking*. Kleinburg,
 Ontario: McMichael Canadian Art Collection.
 This catalogue of an exhibition held at the McMichael Canadian Art Collection
 in 1991–1992 looks at the contribution of the printmakers and the relationship
 between prints and the drawings that inspired them during the first thirty years of
 Kinngait printmaking. It includes essays on the establishment of the West Baffin
 Eskimo Co-operative, the history of Kinngait printmaking, printmaking techniques,
 and selected pairs of drawings and prints.

Gustavison, Susan

1999 *Northern Rock*: *Contemporary Inuit Stone Sculpture*. Kleinburg, Ontario: McMichael
 Canadian Art Collection.
 This catalogue of an exhibition held at the McMichael Canadian Art Collection in
 1999 explores stone as a medium of sculpture. In addition to illustrations of the
 artworks themselves, the book includes detailed discussions of the carving stone of
 four regions from geological, historical, and aesthetic perspectives. Observations
 and opinions from an artist's point of view, grounded in extensive interviews, greatly
 enrich this close study of fifty years of Inuit carving.

Hessel, Ingo

1998 *Inuit Art: An Introduction*. Vancouver: Douglas and McIntyre.
 This is a beautifully illustrated introduction to the art of the Inuit, providing an over-
 view of some major regional, community, and individual artists' styles. Areas covered
 include sculpture, graphic arts, and textiles.

Houston, James

1995 *Confessions of an Igloo Dweller*. Boston: Houghton Mifflin.
 This highly readable, often humorous autobiographical narrative of Houston's years
 in the Canadian Arctic includes many references to artists and others who were piv-
 otal in bringing worldwide recognition to contemporary Inuit art.

Inuit Art Foundation

1986– *Inuit Art Quarterly.*
 Published by the Inuit Art Foundation, this periodical has been a prime resource for
 artists, collectors, academics, dealers, and anyone else interested in Canadian Inuit
 art. An indispensable tool for information on activities, developments, and research.

Lalonde, Christine, and Leslie Boyd Ryan

2009 *Uuturautiit*: *Cape Dorset Celebrates 50 Years of Printmaking*. Ottawa: National Gallery of
 Canada in collaboration with Dorset Fine Arts.
 This exhibition catalogue pays homage to fifty years of printmaking in Kinngait by
 pairing the entire inaugural print collection of 1959 with works from the 2004–
 2009 collections. Although much has been written about Kinngait prints over the
 years, the 1959 collection and the earliest experimental prints have received far less
 attention than later works.

Leroux, Odette, Marion E. Jackson, and Minnie Aodla Freeman, editors

1994 *Inuit Women Artists*: *Voices from Cape Dorset*. Vancouver: Douglas and McIntyre.
 Nine women artists from Kinngait are featured in this book through their biogra-
 phies, memories, and works of art. Additional essays by three Inuit women leaders
 offer further insights into the lives of contemporary Inuit women.

Pitseolak, Peter, and Dorothy Eber

1975 *People from Our Side*: *An Eskimo Life Story in Words and Photographs*. Bloomington: Indiana University Press.

This chronicle of a changing way of life in the Kinngait area, as seen through the eyes of one man, is based on Peter Pitseolak's own manuscript, written in Inuktitut syllabics, and more than 150 hours of interviews by Dorothy Eber. It is illustrated with many of the more than two thousand photographs Peter Pitseolak took of members of his family and everyday life, primarily in the 1940s and 1950s. With the advent of printmaking in Kinngait, he began to document Inuit life even further through drawing.

Routledge, Marie, with Marion E. Jackson

1990 *Pudlo*: *Thirty Years of Drawing*. Ottawa: National Gallery of Canada.

Published in conjunction with an exhibition of the same title, this book traces the growth and maturation of this innovative artist as viewed through his drawings, many of which were never translated into prints. An accompanying biographical essay delves into some of the events and values that helped shape Pudlo's life and, indirectly, his art.

Ryan, Leslie Boyd

2007 *Cape Dorset Prints, a Retrospective*: *Fifty Years of Printmaking at the Kinngait Studios*. San Francisco: Pomegranate.

This sumptuous book celebrates the Kinngait story through the voices of twelve authors who have been intimately involved in its growth and development. The large complement of plates of the artworks themselves, along with numerous historical photographs, make this book a feast for the eyes.

Swinton, George

1999 *Sculpture of the Inuit*. Toronto: McClelland and Stewart.

Originally published in 1972 as *Sculpture of the Eskimo*, this heavily illustrated, classic survey explores sculpture of the Inuit from historical, cultural, and social perspectives. A large section of the book is devoted to a catalogue of artists by area.

Vorano, Norman, with an essay by Asato Ikeda and Ming Tiampo and contributions from
Kananginak Pootoogook

2011 *Inuit Prints, Japanese Inspiration*: *Early Printmaking in the Canadian Arctic*. Gatineau,
 Quebec: Canadian Museum of Civilization Corporation.
 Released in conjunction with a traveling exhibition of the same title, this book is the
 first to explore in detail the close ties between Japanese printmaking traditions and
 the early years of the Kinngait print studio. The author juxtaposes prints brought
 back from Japan by James Houston with the earliest Kinngait prints created after
 his return. Included are essays on the transnational history of Japanese woodblock
 prints and Houston's travel and study in Japan.

Wight, Darlene Coward

2006 *Early Masters*: *Inuit Sculpture, 1949–1955*. Winnipeg: Winnipeg Art Gallery.
 Based on an exhibition of the same title, this catalogue explores early carving in
 three communities—Inukjuak, Puvirnituq, and Kinngait. Highlights of the book are
 accounts of the author's efforts to identify artists and rich artist biographies.